Federal
Philadelphia

The Athens of the Western World

Federal Philadelphia
1785–1825

This publication and exhibition were made possible by a grant from the IBM Corporation.

They were also generously supported by The Pew Memorial Trust, the National Endowment for the Arts, a Federal agency, and the Pennsylvania Historical and Museum Commission.

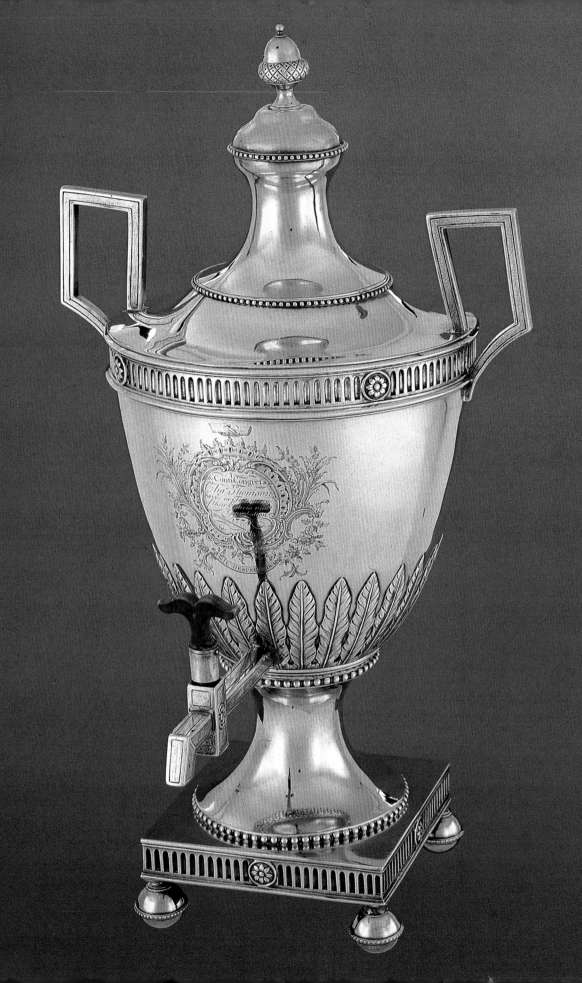

Federal Philadelphia
1785–1825
The Athens of the Western World

Beatrice B. Garvan

Special Photography by
Will Brown

Philadelphia Museum of Art July 5—September 20, 1987

Cover: Detail of sofa from a suite of painted furniture inspired by antiquities, designed by Benjamin Henry Latrobe (pl. 25)

Frontispiece: Grand presentation urn made by Quaker silversmith Richard Humphreys (American, born West Indies, 1750–1832) in 1774, the earliest appearance in American art of the neoclassical style, later to be known as Federal. Engraved by James Smither (American, born England 1741). Silver, height 21$\frac{1}{2}$″ (54.6 cm). Inscribed: the Conti[1] Congress / TO / Chas Thomson / Secry in Testimony / of their Esteem and / Approbation / 1774 / Smither Sculp / NIL DESPERANDUM. Philadelphia Museum of Art. Purchased with funds contributed by the Dietrich Brothers Americana Corporation, 1977-88-1.

Printed in the United States by Princeton Polychrome Press

ISBN 0-87633-069-3 (paperback)
ISBN 0-8122-7958-1 (University of Pennsylvania Press)

Contents

Lenders to the Exhibition

The Athenaeum of Philadelphia

Atwater Kent Museum, Philadelphia

The Cleveland Museum of Art

Cliveden Inc., a Co-Stewardship Property of the National Trust for Historic Preservation

The Committee of 1926 (Strawberry Mansion)

The Cooper-Hewitt Museum, the Smithsonian Institution's National Museum of Design, New York

The Dietrich American Foundation

H. Richard Dietrich, Jr.

Mary Drinker Elek

Mr. and Mrs. Lee F. Driscoll, Jr.

The Commissioners of Fairmount Park

Mr. and Mrs. Stuart P. Feld

Jamee J. and Marshall Field

The Board of Trustees of the First Baptist Church of Philadelphia

Dr. and Mrs. Anthony N. B. Garvan

The J. Paul Getty Museum, Malibu, California

Stephen Girard Collection, Girard College, Philadelphia

Mr. and Mrs. J. Welles Henderson

Dr. and Mrs. Donald M. Herr

The Historical Society of Pennsylvania, Philadelphia

The Thomas Jefferson Memorial Foundation, Inc. (Monticello)

Mr. and Mrs. George M. Kaufman

The Library Company of Philadelphia

Library of Congress, Washington, D.C.

Lynn Historical Society, Massachusetts

Mr. and Mrs. Robert L. McNeil, Jr.

Mr. and Mrs. Louis C. Madeira

The Metropolitan Museum of Art, New York

Mrs. Alan Montgomery

Miss Katharine Johnstone Morrison

Municipal Archives of Amsterdam

Museum of Fine Arts, Boston

National Gallery of Art, Washington, D.C.

National Museum of American Art, Smithsonian Institution, Washington, D.C.

Nationalmuseum, Stockholm

New York Public Library

The Pennsylvania Academy of the Fine Arts, Philadelphia

St. Paul's Episcopal Church, Philadelphia

Mrs. Rodolphe M. de Schauensee

Mr. and Mrs. Irvin G. Schorsch, Jr.

Mr. and Mrs. Raymond V. Shepherd, Jr.

J.B. Speed Art Museum, Louisville

Charles V. Swain

Mrs. Charles J. Swet

Mr. and Mrs. W. Bryce Thompson

George Vaux

The Henry Francis du Pont Winterthur Museum, Delaware

The Naomi Wood Collection at Woodford Mansion, Philadelphia

Yale University Art Gallery, New Haven

Foreword

How would the Philadelphia Museum of Art commemorate the two-hundredth anniversary of the framing of the Constitution of the United States? Many on the Museum's staff addressed the question, especially Beatrice Garvan, with her characteristic zest and energy, and this exhibition represents her imaginative, occasionally surprising, and thoroughly eloquent answer. For the men who drafted the Constitution, and the citizens who argued and pondered over the complex issues it sought to resolve, Philadelphia was not only the largest city in the nation and the capital for ten years, but also a flourishing center for the arts, which found a secure place among the ideals and ambitions of the new nation.

This exhibition draws substantially upon the Museum's collections and it offers an occasion to express renewed gratitude to the many generous donors whose gifts of objects and purchase funds over the years have benefited the American collections. We are also most grateful to the museums, historic sites, and private lenders who have parted with important works of art during the Bicentennial celebration.

The creation of the exhibition and the accompanying publication was the work of many people. Darrel Sewell, together with the staff of the American Art Department, supported Mrs. Garvan in realizing her goal within a short span of time. We owe to Richard Meyer the inventive installation design, which evokes the neoclassical forms of the Federal city, and to George Marcus, the organization and visualization of this catalogue, corresponding to Mrs. Garvan's conception of her subject. Virtually the entire staff of the Conservation Department was involved in this major effort. The realization of the complex installation was carried out with care by the Museum's technicians and installation crew, and the concern of Lawrence Snyder for every aspect of the project contributed much to its achievement during a particularly busy year.

A major grant from the IBM Corporation made this exhibition and publication possible. In its sponsorship of the "Thomas Eakins" exhibition five years ago, IBM confirmed itself as an impressive and sympathetic partner in cultural ventures, and we are warmly appreciative of IBM's interest in this contribution to the celebration "We the People" in Philadelphia. We are also deeply grateful to The Pew Memorial Trust and the National Endowment for the Arts, which have generously supported so many of the Museum's major exhibitions, and to the Pennsylvania Historical and Museum Commission, which funded a portion of the extensive conservation work for this project. Heartfelt thanks are also due to the Luce Fund for Scholarship in American Art, which has supported Mrs. Garvan's research on the Museum's American silver and metals, from which new insights and information have emerged and have helped to shape the exhibition.

Anne d'Harnoncourt
The George D. Widener Director

Preface

In honor of the 200th anniversary of the Constitution, which was written in Philadelphia, and because there has never been a major exhibition about Philadelphia in this exciting Federal period, it seemed timely to celebrate one event with the other. This project is an exhibition about a place, Philadelphia, during a specific period, 1785 to 1825, when the eyes of the world were focused on the proceedings and results of the Constitutional Convention, and the years immediately following, when Philadelphia was the capital city of the new nation. To this end we have brought together a wide range of objects in various mediums that touch upon many facets of Philadelphia life of that time. To this richesse we have added selections from the primary sources—letters, diaries, and accounts—to form a more complete picture. This is an anecdotal introduction to Philadelphia in a most exciting and provocative era. There was no intent here to be encyclopedic but rather to show what people saw and what they thought about daily life in the city, about national issues, about the changes in social life, and about the emergence of the fine arts into the public domain. It was a period of terrific innovation and experimentation, when Philadelphia was deeply concerned about international events in England and Europe.

This is an interpretive approach. The objects selected both demonstrate and illustrate the six themes "Victory," "The Republican Court," "The Athens of the Western World," "Vive la France," "A Sense of Style," and "A Moment in the Arts." It became clear that each object had more than one story to tell, so that narrowing the focal points has been a challenging endeavor and I have many people to thank for sharing their particular projects or expertise.

To accomplish this task, I have drawn upon the considerable skills of colleagues and I would like to thank them for their invaluable participation in this project. To Anthony N. B. Garvan, for everything; to Anne d'Harnoncourt, who supported with applause and critiques at just the right times; to John Van Horne, whose knowledge of resources was generously shared from his own scholarship about Benjamin Henry Latrobe; to Jeff Cohen and Ted Carter, my thanks for sharing their thoughts and materials to be included in the forthcoming Latrobe drawings catalogue; to Charles E. Peterson, for sharing his discovery of the architect for the Bingham House; to Betty Starr Cummin, whose "French connections" and bubbling enthusiasm for things French facilitated a vital aspect of our installation; to Sam Dornsife, who pursued answers to my textile design questions; to Donald Fennimore, who encouraged speculation about attributions; to Charles Hummel, who shared insights and analyses of special objects; to Deborah Mattson, who carried rare tomes across the Atlantic; to Darrel Sewell, who watched over the whole; to

George Marcus, who encouraged, prodded and corrected numbers of attempts at essays and entries; to Don Kaiser, who worked long hours on the Museum's version of Latrobe's wall painting; to Kathryn Hiesinger and Peter Thornton, who advised on the particulars of Jefferson's French wallpaper; to Simon Jarvis, who helped me pursue sources for the brass patterns inlaid into furniture; to Richard Meyer, architect extraordinaire, who started with some ideas and made a city out of them; to Lulu Lippincott, whose scholarly interest encouraged the pursuit of the Bonapartes; to all our lenders whose "Of course, why not?" responses to my early pursuit of Philadelphia's finest objects made the exhibition possible; and to the Museum staff, including in Special Exhibitions, Suzanne Wells, Dave Wolf; in Public Relations, Sandra Horrocks, Barbara Jordan; in Operations and Gallery Installations, Lawrence Snyder, Barney McNellis, Lee Savary, Warren Henderson; in the Registrar's Office, Grace Eleazer; in Publications, Jane Watkins, Phillip Unetic, John Paschetto, Mary Kinsella, Nancy Stock-Allen, Charles Field; in Conservation, Marigene Butler, Andrew Lins, Dante de Florio, Jr., Michael Rasmussen, Melissa Meighan, Randall Couch; in the Library, Barbara Sevy, Tom Donio; in Rights and Reproductions, Conna Clark; in Costume and Textiles, Dilys Blum; in American Art, Jack Lindsay, Kate Javens—and especially Will Brown for his splendid photographs.

B.G.

Victory

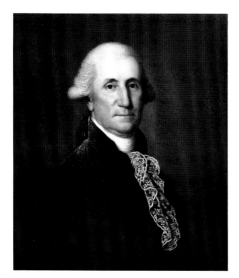

Figure 1
Portrait of George Washington, by
Adolph-Ulric Wertmüller (Swedish, died
America, 1751–1811), 1794. Oil on can-
vas, 25⅜ x 21⅛" (64.4 x 53.7 cm).
Philadelphia Museum of Art. Gift of Mr.
and Mrs. John Wagner, 1986-100-1.

With the signing of the Treaty of Paris on September 3, 1783, the
Revolutionary War was diplomatically over. The treaty became official in
Philadelphia when news of it was received from abroad and proclaimed
from the court house balcony at Second and Market streets. But ever
since Philadelphians had heard about the surrender at Yorktown on
October 19, 1781, they had begun to advance their own trade and
commerce.

Pennsylvania, and especially Philadelphia, which had been the com-
munications center during much of the war, found itself again at the
center of political and commercial activity. This gave Philadelphia a huge
advantage over New England and the South, whose livelihoods had
depended on their British connections. Philadelphia had been founded as
the mercantile center of Penn's Quaker settlement. Although the Revo-
lution had caused rifts in some Quaker families because their young men
wanted to take part in forbidden military actions, it had simply postponed
other Quaker enterprises. The close-knit organization of Quaker family
contacts and trade not only was still in place but, in some instances, had
even developed discreetly during the war, and the continuance of the
Quakers' trade was assured as new markets and resources developed with
closer ties to France and with the first adventures to the Far East. Ports
such as Boston and Charleston, on the other hand, not only had to rebuild
their trading ships but also had to develop new contacts abroad. The
Revolution had decimated the American fleet, and British shipping
merchants took full advantage initially of America's weakness at sea and
in manufacturing, deluging all ports with surpluses stockpiled during the
war. New partnerships were slowly formed and new capital amassed in
seacoast towns, but Philadelphians took advantage of old credit secured
by family ties and continued their prosperous trade.

Before the war Philadelphia had been the commercial and intellectual
capital of the colonies. It moved into a "capital" position again in 1787, as
the city of the Constitution, and in 1790, as the seat of the new govern-
ment. Likewise, between 1781 and 1787 Philadelphia reestablished its
reputation as America's most cosmopolitan city. Its amenities attracted
settlement, permanent and temporary. The new generation was in high
spirits and ambitious. Old customs and ideas lingered, but the primary
goals of the city were tied closely to public events and the establishment
of the United States. The will of the majority generally was for unifica-
tion, a sentiment that affected the entire life of the city, not just its
politics. The influx of people from other regions as well as foreigners,
however, caused some reshuffling of Philadelphia's social deck of cards.

In the decade 1789 to 1799, the course of the French Revolution not
only celebrated America's successful one but also brought Philadelphia

again into the controversies and debates about royalty. There was great curiosity about the French, their customs and their "style," which was considered exotic. Earlier generations in Philadelphia had absorbed French arrivals, in the late seventeenth and early eighteenth centuries, when Huguenots from the Alsatian region of France came in large numbers to escape persecution after the revocation of the Edict of Nantes.[1] These settlers and now their descendants were superb farmers, weavers, and ironworkers, and they continued to produce materials for Philadelphia's booming trade. The French who came late in the century were more urban than rural. There were craftsmen among them but also members of the royal court. They fascinated Philadelphia and were often the subject of colorful news. The distressing aspects of the French Revolution, together with positive feelings about the French king's earlier support for the American cause, put Philadelphians in a sympathetic frame of mind toward the French aristocracy in residence. Elizabeth Drinker's opinion was written on January 11, 1794: "An affecting account in the Paper of this day, of the trial and Death of the Queen of France, beyond description cruel."[2]

Such sentiments were general and may have fostered some nostalgia for the glamour of an aristocracy. The prominent Quakers who controlled the city through the meetinghouse began to be replaced by a different group, involved more with the power of state than that of church and with securing the freedoms recently won. They took as their hero George Washington. He fulfilled all the criteria of leadership. He was the ideal. Washington's stature, regal bearing, reserve, and dignity made him seem an American "monarch" personifying truth, temperance, and justice. The impressive portraits of Washington emphasize these attributes (see fig. 1). Philadelphians saw no irony in the similarities between their fêtes honoring the birth of the dauphin of France in 1781 and their celebrations of Washington's passing through the city at various times or of his birthday in 1788. Americans were eager to secure their new ship of state, and Washington was their image of a proper and distinguished skipper. In public he showed a calm, cool demeanor; he exuded self-confidence as he led in a quiet but firm style. Citizens of all regions identified with him more than with the words in the new Constitution. He became a father figure in the eyes of most. Philadelphia was his presidential headquarters, and Philadelphians, Quakers and all, placed him at center stage. When John Adams succeeded him, Adams expected that the spotlight on Washington would dim a bit, if not turn completely in Adams's direction. Abigail Adams in a letter to her sister in 1798 complained that Washington, however, still held attention:

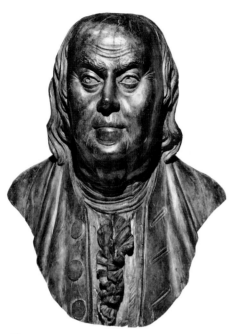

Figure 2
Bust of Benjamin Franklin, by William Rush (American, Philadelphia, 1756–1833), c. 1787. Pine, height 20¼″ (51.4 cm). Yale University Art Gallery, New Haven. The Mabel Brady Garvan Collection.

These Philadelphians are a strange set of people, making pretentions to give Laws of politeness and propriety to the union. They have the least feeling of real genuine politeness of any people with whom I am acquainted. As an instance of it, they are about to celebrate, not the Birth day of the first Majestrate of the union as such, but of General Washingtons Birth day, and have had the politeness to send invitations to the President, Lady and family to attend it. The President of the United States to attend the celebration of the birth day in his publick Character of a private Citizen! For in no other light can General Washington be now considered, how ever Good, how ever great his Character, which no person more respects than his Successor. But how could the President appear at their Ball and assembly, but in a secondary Character, when invited there, to be held up in that light by all foreign Nations. But these people look not beyond their own important selves. I do not know when my feelings of contempt have been more calld forth, in answer to the invitation. The President returnd for answer, "that he had received the card of invitation, and took the earliest opportunity to inform them, that he declined accepting it." —That the Virginians should celebrate the day is natural & proper if they please, and so may any others who chuse. But the propriety of doing it in the Capital in the Metropolis *of America as these Proud Phylidelphians have publickly named it, and inviting the Head of the Nation to come and do it too, in my view is ludicrious beyond compare.*[3]

Washington's popularity increased that of his favorite entertainment, the theater. His visits were public appearances that delighted everyone and offered opportunities for pomp and homage. He always stole the show. Even the theater companies were delighted, as his presence increased the gate:

The East stage box was fitted up expressly for the reception of General Washington. Over the front of the box was the United States coat of arms; red drapery was gracefully festooned in the interior and about the exterior. The seats and front were cushioned. Mr. Wignall, in a full dress of black, hair powdered and adjusted to the formal fashion of the day, with two silver candlesticks and wax candles, would thus await the General's arrival at the box door entrance.[4]

If George Washington embodied the honor and the glory of Federal America, Benjamin Franklin was the old sage who observed and commented on events. Like Washington, he was a "worthy" in everybody's diary. He was the epitome of the American intellectual in the eyes of the world, and Philadelphians honored him for it. His Quaker-like simplicity

was celebrated abroad and probably allowed Philadelphians a personal identification with his moments of international acclaim. Franklin (fig. 2) was the figurehead and the world's image (in spite of Washington's majestical presence) of what America was about, and he played out this role of the grand old personage in the Constitutional Convention in 1787. But younger savants such as Thomas Jefferson led the United States as a nation through the formative period, by loosening the strings of regional sovereignties, and into an era of building on the foundation of an untried document, by restoring confidence, promoting enlightened thinking about government institutions, and encouraging every phase and aspect of the arts. Everywhere after the war there was controversy about the oath of allegiance, the treatment of Tories, back military pay, inadequate coinage, and the eroding value of paper money. Although not yet a governing body with centralized legal powers, Congress dealt with such national issues on an emergency basis. One of the most significant measures passed was the copyright provision of 1789. It stated loud and clear that protection of individual rights and of property in the form of "Writings and Discoveries" would have highest priority. Experimentation and creativity in all fields was the result.

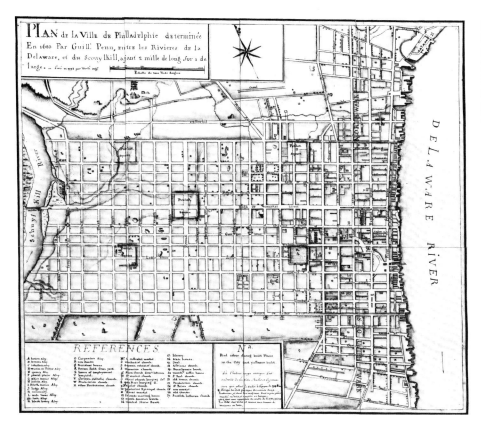

Figure 3
Plan de la Ville de Philladelphie, showing the dense development east of Tenth Street. Drawn by Peter Charles Varlé (American, born France, active 1794–c. 1835), 1794. Watercolor and ink on paper, 16¹¹₁₆ x 18¹¹₁₆" (42.4 x 47.5 cm). Municipal Archives of Amsterdam.

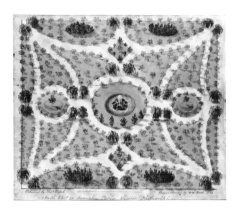

Figure 4
*North East or Franklin Public Square,
Philadelphia*, exemplifying nineteenth-
century Philadelphians' concern for the
parks first laid out by William Penn.
Drawn by William Rush and colored by
Thomas Birch (American, born England,
1779–1851), 1824. Watercolor and ink
on paper, 15³⁄₄ x 17³⁄₄" (40 x 45.1 cm).
The Library Company of Philadelphia.

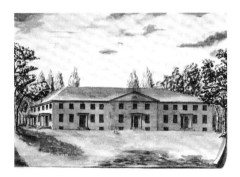

Figure 5
*The Fourth Street Meetinghouse, Phila-
delphia*, typical of the simple architecture
used for Quaker meetinghouses. Detail
of the elevation and plan drawn by Owen
Biddle (American, 1774–1806), 1803.
Watercolor on paper, 16 x 16" (40.6 x
40.6 cm). The Athenaeum of Phila-
delphia. Gift of George Vaux, 1983.

The city plan in 1794, as drawn by Peter Charles Varlé, a French
engineer, for promotion of Robert Morris's Holland Land Company,
showed the city developing slowly from the Delaware waterfront, having
reached only Tenth Street (fig. 3). Varlé's drawing shows increased
density along the Delaware, a clear indication that Philadelphia was
continuing to build its sea trade and that dockside was still highly desir-
able real estate. James Hamilton's country property Bush Hill and
William Penn's Springettsbury are drawn in some detail just under the
legend, beside a canal in the planning that would have joined the Dela-
ware with the Schuylkill River above the latter's falls and thus would have
facilitated commerce with western lands.

Penn's town plan was basically intact in 1794, although the Varlé plan
shows that major streets crossed what Penn had designated as public
squares, which were to remain green parks. An 1824 watercolor of
Franklin Square, drawn by William Rush and colored by Thomas Birch
(fig. 4), suggests, however, that in the early nineteenth century Phila-
delphians became interested in retaining and even restoring the pleas-
anter aspects of Penn's plan.

Despite its political and cultural prominence in Federal America,
Philadelphia remained surprisingly simple in appearance. Late eigh-
teenth-century views of Philadelphia show a city densely built along the
Delaware River but lacking a particularly distinguished skyline (fig. 6).
The few lofty spires were far less impressive to visitors than the forest of
ships' masts along the wharves. The Quaker meetinghouses did not have
steeples (fig. 5), while many of the churches, such as St. Paul's, St. Peter's,
and the First Baptist, and even the State House had modest, practical bell
towers. But there any appearance of modesty ended. Except for the
Quaker meetinghouses, these buildings had the most elaborate interior
woodwork, which was ornamented with painting, carving, and often
gilding, and their communion services were commissioned from promi-
nent silversmiths such as Christian Wiltberger and James Black, who
created weighty objects in conservative designs (see fig. 7).

Philadelphia was never a plain city, although visitors' impressions of
brick walls and houses punctuated by the steady rhythm of white win-
dows and pedimented doorways generally imply that the city had a
tiresome if pleasant orderliness. Some thought it boring, others were
impressed with the resulting regularity and neatness:

*Philadelphia is an elegant and well constructed city, vastly superior in
external appearance to any we have seen. Though an entire stranger, I can
find any street and even house without enquiring. The streets are very
spacious and clean and the sidewalks in every street wide enough for five or*

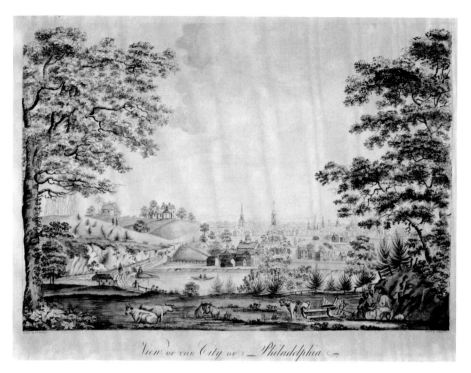

Figure 6
View of the City of Philadelphia, from the north, showing the city's development at the close of the eighteenth century. By Gilbert Fox (English, London, 1776–c. 1806) after John Joseph Holland (American, born England, c. 1776–1820), c. 1796. Etching with watercolor, 15 x 20¹³⁄₁₆″ (38.1 x 52.9 cm). The Henry Francis du Pont Winterthur Museum, Delaware.

six persons to walk abreast, handsomely paved with brick. The streets all cross at right angles and are perfectly straight. . . . You will perhaps be surprised when I tell you that there is only one steeple in the city and only one bell rung on the Sabbath.[5]

Most important, however, the distinction of class, which obsessed Europeans, was not easily discerned in Philadelphia's architecture. Buildings did not clearly reveal personal status. Many people rented living quarters, and even those who owned a house often rented the first floor as a shop or an office and lived in the upper stories. Some of the finest domestic architecture in the early Federal period, such as the house built in 1796 by Samuel Allen at 227 South Third Street, was built for investment. The plentiful regional materials, such as brick and marble, and the craftsmen, who were trained in apprenticeships, guaranteed continuity of style in the tidy city. Tall doorways and large windowpanes were details that distinguished Philadelphia houses in the Federal period. The front doorframe from a house once located at 214 South Eighth Street shows a combination of rococo and Federal motifs often found in late eighteenth- and early nineteenth-century Philadelphia architecture (fig. 8). The paneled door is set deep behind fully rounded columns and beneath a heavy pediment—an arrangement typical of grander prewar doorways—but

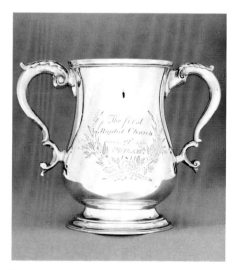

Figure 7
Two-handled cup in the rococo style. By James Black (American, Philadelphia, active 1795–1819), 1811. Silver, height 5⁵⁄₁₆″ (13.5 cm). Inscribed: The first/Baptist Church of PHILADᴬ/1811. First Baptist Church, Philadelphia.

Figure 8
Doorframe from 214 South Eighth Street,
Philadelphia, 1785-1800. Painted pine
and poplar, height 132″ (335.3 cm).
Philadelphia Museum of Art. Purchased:
Thomas Skelton Harrison Fund, 40-3-1.

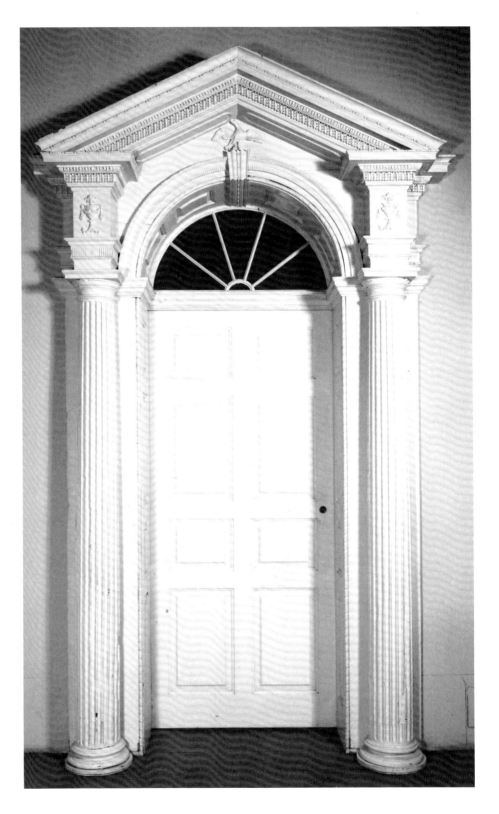

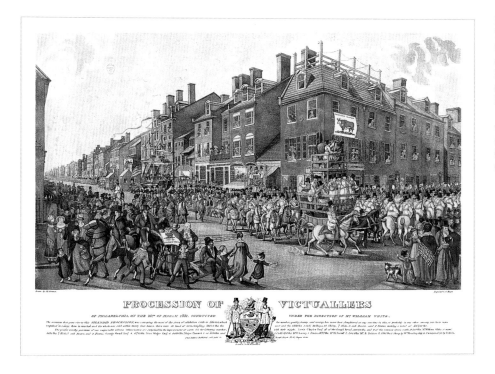

Figure 9
The Procession of Victuallers, at Fourth and Chestnut streets, Philadelphia, with the city's conservative, brick façades in the background. By Joseph Yeager (American, c. 1792–1859) after John Lewis Krimmel (American, born Württemberg, 1786–1821), 1821. Aquatint and etching with watercolor, 14⅜ x 23¾" (36.5 x 60.3 cm). Philadelphia Museum of Art. Gift of the estate of Charles M. B. Cadwalader, 61-7-17.

the frame is decorated with the classical ornament in bas-relief and the repetitive, simple carving found so often on Federal woodwork. The many marble quarries close to the city insured that this material would be used consistently for front steps, adding to the smooth effect of uniform street façades. The insurance companies that dictated the specifics of some construction in order to grant fire insurance contributed to the similarity of design among the grander houses.[6] Philadelphia was thus an architecturally charming city in the 1780s, and even when a later artist such as John Lewis Krimmel painted street scenes, the warm glow of pink and red brick buildings gave his populous, lively foregrounds a solid, homogeneous setting. *The Procession of Victuallers* (fig. 9), an 1821 aquatint by Joseph Yeager after Krimmel's drawing, shows that, well into the nineteenth century, the central mercantile area in Philadelphia, Chestnut at Fourth Street, had not been remodeled with cut stone and stucco, materials that were gaining in favor by 1800.

Penns' Proprietary Interests

Plate 1
Tankard
Joseph Anthony, Jr. (American, Philadelphia, 1762–1814)
1788
Silver, height 6⅞″ (17.5 cm)
Inscribed: Presented by John Penn Junr /
& John Penn Esqrs to Mr Charles / Jarvis
as a Respectful acknow / ledgment of his
Services 1788
Philadelphia Museum of Art. Purchased,
50-53-1

The citizens of Great Britain heard about the preliminary peace treaty of November 30, 1782, between America and Great Britain, almost immediately. The news did not stir up much political activity in England, but the reopening of American ports spurred English merchants and their agents to renew mercantile contacts and to collect old debts. As America was about to become a sovereign nation, the Penn family were caught in a particularly difficult situation. Their capital interests in Pennsylvania were in land, and they also received annual payments, called quitrents, from Pennsylvanians owning property. The Penns feared that their proprietary rights to Pennsylvania quitrents and lands not yet purchased or allocated would not be recognized by the new governing body.

Thus John Penn, Jr., son of Thomas Penn, once the proprietor of Pennsylvania, and grandson of William Penn, the founder of the province of Pennsylvania, faced losing the major share of his inheritance. He left London and arrived at Philadelphia in 1783; he lived temporarily with his older cousin also named John Penn at Sixth and Market streets, in a house that Robert Morris later bought and then leased to Washington during his presidency. John Penn, Jr., might have intended to reside permanently in Philadelphia, because in 1784 he bought fifteen acres of land on the west bank of the Schuylkill River

and set about drawing designs in his commonplace book for a small, elegant, bachelor's villa, which he named Solitude.[7] His primary intent was to see for himself how much he could salvage of his American investment; probably to this end he and his cousin hired Philadelphia lawyers Charles Jarvis and Gunning Bedford. The Penns' petition was turned down, however, in 1787 by the Pennsylvania legislature.

In February 1788, amid all the excitement about the progress of the ratification of the Constitution, the older John Penn bought two tankards from Philadelphia silversmith Joseph Anthony, Jr.[8] They were engraved with the Penn arms and with similar inscriptions for presentation to the lawyers Jarvis and Bedford in grateful recognition of services rendered.[9] Unsuccessful in attempts to retain proprietary rights over land now claimed by the state or to collect any more quitrents, John Penn, Jr., returned to England in 1789, while the older John Penn lived in Philadelphia until his death, in 1795.

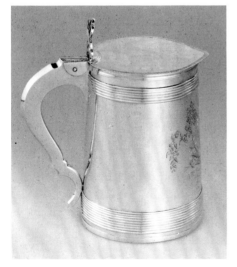

Figure 10
Side view of tankard.

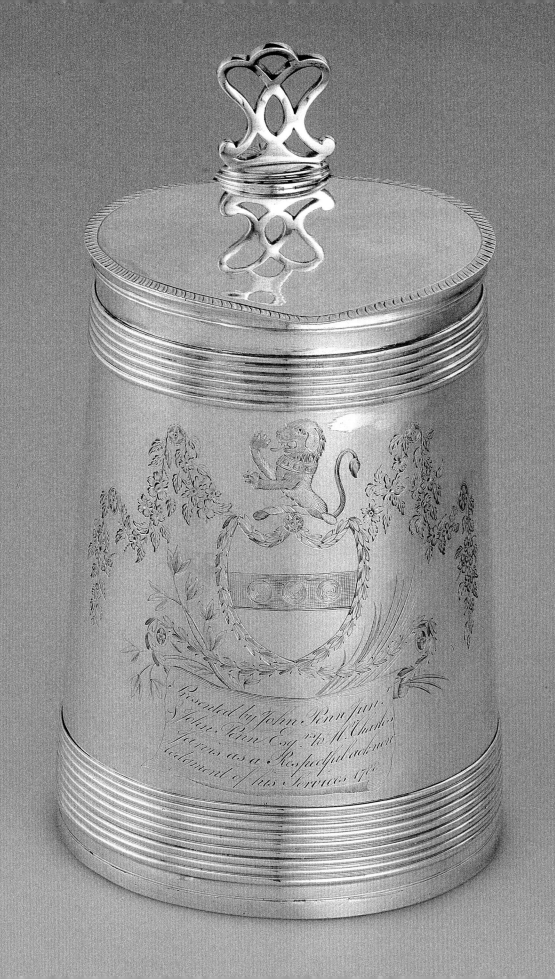

Plate 2
Card Table
David Evans (American, Philadelphia,
1774–1814)
1788
Mahogany, white pine, and gilded brass;
29¹⁄₂ x 35¹⁄₂″ (74.9 x 90.2 cm)
Philadelphia Museum of Art. Purchased,
50-104-1

This card table is a fine example of a design that was used both before and after the Revolution. David Evans, cabinetmaker, and Edward Burd, for whom Evans made this table and its mate (location unknown), were leading citizens of Philadelphia before the war.[10] They were typical of many craftsmen and their patrons who simply continued after the war to prefer the old Philadelphia style of solid wood construction without veneers and with understated ornamentation. The four different moldings used to embellish this table are an integral part of its design, which is distinguished by its architectural quality. The fine bead at the lower front edge was popular in Philadelphia and was used on card tables by other Quaker cabinetmakers, such as Thomas Affleck, who also worked both before and after the war.

The gilded brass handles are original and were made at one of the prolific metal foundries of Birmingham, England. Birmingham metal shops supplied hardware to most of England, some of Europe, and initially all of America. Everything from cutlery, pans, fittings for curtains, carpet rods, pulleys, and corkscrews to door and furniture hardware and harness fittings was available.[11] Hardware catalogues were illustrated with engraved plates and were issued repeatedly; new styles were added on new pages. Dating the earliest appearance of a style based on these printed catalogues is difficult and presently depends upon the watermarks of the paper they are printed on.

The gilded brass handles on the Evans table may have been in Evans's stock from before the war or may have been in one of the crates of surplus goods that the British dumped on the Philadelphia market after the war. These handles are typically English in their design but were out of fashion there by 1788. The bails, identical to one illustrated in a Birmingham catalogue probably from the 1770s (fig. 11), were made in the rococo style of the early eighteenth century, but the post plates show the influence of the mid-century neoclassical style of Robert Adam.

Another page in this hardware catalogue shows post plates very similar to the ones used on this table, beside other hardware with tight, abstract leaf forms and beaded edge bands, clearly designed in the Adam style. The objects in these engraved plates were pictured in exact size and detail; some pages show several sizes of the same design. The bail on this table is exactly the same size as the one illustrated. The mix and match possibilities that these catalogues offered make clear that, while Evans was supplying Burd with his card tables in an old-fashioned style, newer styles could creep gradually into Philadelphia shops.

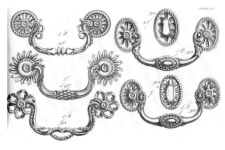

Figure 11
Drawer handles illustrated in a hardware catalogue from Birmingham, England, 1770–80, including at the lower left a bail identical to those used on the card table. Engraving, 6 x 9⁵⁄₈″ (15.2 x 24.4 cm). Library of the Philadelphia Museum of Art.

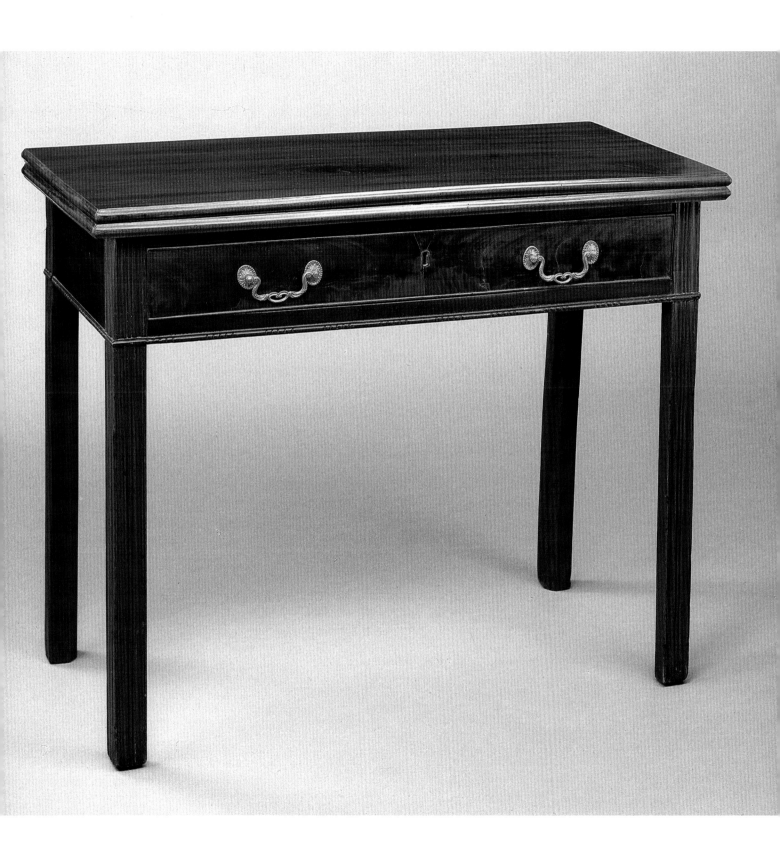

The Republican Court

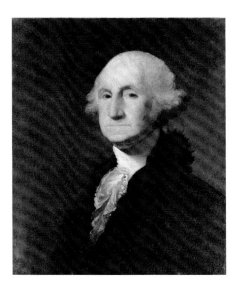

Figure 12
Portrait of George Washington, by Gilbert
Stuart (American, 1755–1828). Oil on
canvas, 28 x 24″ (71.1 x 61 cm). Phila-
delphia Museum of Art. Gift of
Mr. and Mrs. Wharton Sinkler, 57-67-1.

When George Washington was elected president, it was as if a king were
crowned, and Gilbert Stuart's full-length portraits of him lack only the
ermine robes of English royalty to complete the illusion. Full length or
head and shoulders (fig. 12), Stuart's paintings portray the power and the
glory of Washington as he acted out his leadership role. In his official
capacity, Washington wore black, either satin or velvet, with a smart lace
ruff at his neck and a white powdered wig, as Adolph-Ulric Wertmüller
painted him in 1794 (see fig. 1). His costume may have been conservative
but with his commanding height and manner, Washington completely
dominated his "Republican court," which dressed in colorful silks with
embroidered waistcoats and pastel-colored knee breeches. Women,
bejeweled and with extravagant plumes in their headdresses, fluttered
around him. He enjoyed it, and throughout the 1790s, when Philadelphia
was the capital, he and the First Lady were the center of the social whirl.

Carefully contrived assemblages made up the Republican court.
Although long the practice in England and France, the use of the drawing
room, where ladies were very much in evidence, as an arena for testing
political opinions did not become prevalent in America until the Federal
period. Hostesses who managed salons had wit, grace, and skill and were
recognized for their role. Old-fashioned protocol was abandoned in favor
of an international style. Mrs. Washington, Mrs. Robert Morris, and Mrs.
William Bingham were the reigning queens. They entertained often, and
if diarists' comments are taken as evidence, the Federal salon was brilliant
and useful. Neutral territory where social rules and manners dominated,
it protected the indiscreet and allowed the brave to try out new ideas. Hot
issues were not debated in these situations; it was innuendo that maneu-
vered one through; alliances and sympathies were observed by noting
who talked to whom and when. Washington himself set business aside
when in the company of women, deflecting political encounters, and was
therefore counted on to be a suave, reserved guest whose manner would
smooth tensions as they arose. He was an accomplished gentleman,
following his own fifty-four "Rules of Civility and Decent Behavior in
Company," such as "Undertake not to teach your equal in the art himself
professes; it savors of arrogancy," or "Play not the peacock looking every
where about you to see if you be well decked, if your shoes fit well, if your
stockings sit neatly, and clothes handsomely."[1] Washington was an
exceedingly sociable man, and he attended a seemingly endless round of
functions, formal and informal. He traveled by his white coach-and-four,
usually in the company of men of affairs. On May 23, 1787, for example,
he noted in his diary that, because no more states had yet arrived to
present credentials to the convention, he could visit country estates along
the Schuylkill River. He dropped in on General Mifflin for breakfast,

where he picked up Madison, Rutledge, and others, and went across the Schuylkill at the falls to visit Peters. Then he went to Penn's (Lansdowne) and Hamilton's (Woodlands), after which he had dinner at Chew's (on Third Street), attending the wedding celebration of Chew's daughter. He stayed there drinking tea "in a very large circle of ladies."[2]

The list of people who attended major entertainments in Philadelphia during the period from 1787 to 1800 includes every distinguished American politician, writer, artist, and intellectual, as well as foreign nobility. When the United States was organized and began to receive delegations from foreign nations, they too made an impression on Philadelphia's social scene. The worldly mix forced change in Philadelphia's style. Multilingual conversations about world affairs and subjects such as art, music, science, and theater, less volatile than national politics, were safe for social gatherings, and the sophisticated Europeans and learned travelers who brought the latest ideas about these subjects were in great demand. They heightened awareness in Philadelphia of the widening role of the United States as it grew into full competition with the world powers.

The salons of London and Paris were the models that William and Anne Bingham followed in their grand house at Philadelphia. Typical of the attitudes that helped women to enter political conversations, Anne Bingham's habit was to state her opinions, sympathies, and patriotism under the cover of a witty manner. The Binghams brought regency London into Philadelphia. Some of it was absorbed; some caused comment. In his *Recollections*, Samuel Breck mocked the Binghams' habit of having guests' names announced by the servants as the former passed from the entrance up to the drawing room.[3] Gilbert Stuart's portrait of Anne Bingham (fig. 13) shows her in a conservative mode, but correspondence between Molly and Hetty Tilghman describes the Anne Bingham, "queen of the Republican court," that the city celebrated and remembered after her death, in 1801, at age thirty-seven:

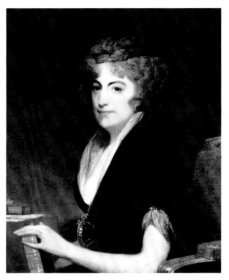

Figure 13
Portrait of Anne Willing Bingham, by Gilbert Stuart, 1797. Oil on canvas, 29¾ x 24¾" (75.6 x 62.9 cm). Private collection.

One piece of intelligence respecting Mrs. Bingham's elegance . . . she blaz'd upon a large party at Mr. {Robert} Morris's in a dress which eclips'd any that has yet been seen. A Robe a la Turke of black Velvet, Rich White Sattin Petticoat, body and sleeves, the whole trim'd with Ermine. A large Bouquet of natural flowers supported by a knot of Diamonds . . . Her Head ornamented with Diamond Sprigs interspers'd with artificial flowers, above all, wav'd a towering plume of snow white feathers. Can you imagine a dress more strikingly beautiful?[4]

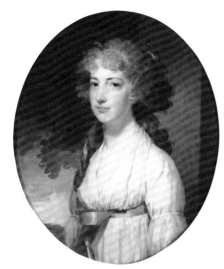

Figure 14
Portrait of Elizabeth Beale Bordley, by Gilbert Stuart, c. 1796. Oil on canvas, 29¼ x 24¼" (74.3 x 61.6 cm). The Pennsylvania Academy of the Fine Arts, Philadelphia. Bequest of Elizabeth Mifflin.

Figure 15
Mourning picture in memory of George Washington by Samuel Folwell (American, Philadelphia), one of the few known teachers of decorative painting in Federal Philadelphia. c. 1800. Needlework and paint on silk, 20½ x 24" (52.1 x 61 cm). Private collection.

People flocked to Philadelphia during this period precisely because it was the center of intellectual and social change. Governmental appointments also moved important citizens to the city. In 1791 John Beale Bordley was appointed one of the commissioners for the Bank of the United States, and he and his family, including his only daughter Elizabeth (fig. 14), left their plantation Wye in Maryland, moved to a house on Union Street in Philadelphia, and rented a summer house on the Schuylkill River.

The years from 1790 to 1800 were important to the changing image of women. Not only did women move in public life with much more aplomb than before; it was also not considered bad form to be noticed in public, to be a topic of conversation, or to participate in lively, public affairs. Comments written during this period make frequent reference to the well-educated and well-informed Philadelphia women and include some comparisons with women in other cities: "Few New York Ladies know how to entertain company in their own houses unless they introduce the card-table. . . . With what ease have I seen a Chew, a Penn, Oswald, Allen and a thousand others entertain a large circle of both sexes, and the conversation without the aid of cards not flag or seem the least strain'd or stupid."[5] The Marquis de Chastellux commented about Mrs. Samuel Powel, "She is well read and intelligent; but what distinguished her most is her taste for conversation, and the truly European use that she knows how to make her understanding and information."[6] Mary Binney wrote in Philadelphia in 1806 that "Madame Moreau, wife of the General, is at present the magnet of all attraction. Her accomplishments are indeed wonderful, and it seems to me her husband takes his consequence from her now, however he *reflected* honor in France."[7]

Education of well-to-do women in Philadelphia included household management, reading, languages, and some competency at drawing and painting and music. Most young women, no matter what their social level, learned some needlework. After the death of Washington, memorial pictures in embroidery, painting, and even hairwork abounded (fig. 15). Samuel Folwell, one of the few teachers to be identified, advertised, "All Kinds of Pencil Work will be taught, as also Painting upon Sattin, Ivory, Paper: that curious Art of working Devices in human hair, in which he has long had professional Practice in this City, will also be taught. . . . The Terms are Eight Dollars per Quarter."[8]

Philadelphia women were not the slightest bit self-conscious about pursuing solid learning in an era when it was not fashionable to be considered bookish. Abigail Adams wrote that, among all her friends, Elizabeth Powel was "the best informed, beside which she is friendly, affable, good, sprightly, and full of conversation,"[9] and Joshua Fisher

commented that Mrs. Gabriel Manigault's "taste for literature made her house the centre of all the educated men and women of her time."[10] Young or old, nearly everyone read books. Harriet Manigault noted that in the afternoon she read the *Spectator* and in the evening aloud from a novel: "Our present one is 'Modern Philosophers,' which is a very droll thing."[11] Deborah Norris Logan was fascinated by Napoleon, commenting on him and reading Warden's *Buonaparte at St. Helena,* and she delighted in Sir Walter Scott.[12] Elizabeth Drinker read Lavater's *Physiognomy; The Life of Mahomet,* by Humphrey Prideaux; *The Farmer's Friend,* by Enos Hitchcock; and W. Hutton's *Journey from Birmingham to London,* to name a few.[13] Reading was not reserved for the wealthy: books were available at lending libraries. This was an era when females of all ages with a literary bent wrote elegant letters and diaries. The diary of Deborah Logan is written in a beautiful, clear hand and was inspired by a lively and curious mind. She criticized everything and everyone from Jefferson to Monroe, while she penned deeper thoughts with eloquence—"It is truly said that we dance over pitfalls covered with Flowers."[14]

At this time some women in Philadelphia were recognized for their professional status. Benjamin Rush honored the nurses Mary Waters and Mrs. Marshall, who devoted their lives to care for the sick. Several women of the Peale family were professional artists, and Mary Wrench Rush (Mrs. Jacob Rush) (fig. 16) was acknowledged as a proficient miniaturist. She had been a pupil of Charles Willson Peale, and his portrait of her, painted in 1786, shows the tools of her trade in the foreground.

The Quakers were not participants in the swirl of the Republican court, but they were curious onlookers as shown by letters and diaries. After the Revolution some Quakers renewed with vigor their tenets of simplicity and plainness. Others wanted to stay in step with the city and justified their coaches, for example, as "conveniences." Throughout this period Quaker families kept up their own pattern of life and their own flow of social intercourse, which was as rigorous as any that George Washington or Anne Bingham practiced. Elizabeth Drinker described a Sunday in March 1794 in her diary:

First Day: Our lodgers, W'm. Newbold and others breakfasted—W'm. and self stay'd at home, Molly also—John Lloy'd, Mark Reeve, Warner Mifflin, William and Sarah Blaky, John and R. Watson din'd with us—Hannah Catheral, R. Jones, Sam'l Trimble, widdow King from New-York, her Son Ray King, at tea—John Balderston left us this even'g—his wife being unwell—a fine day—Becky Wharton Anna Wells, call'd—A Skyrin and child—Abraham Gibbons and Wife, Dan'l. Smith & c. sup'd here.[15]

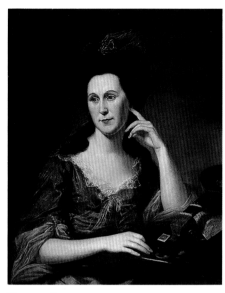

Figure 16
Portrait of Mary Wrench Rush, by Charles Willson Peale (American, 1741–1827), 1786. Oil on canvas, 33¼ x 26½" (84.4 x 67.3 cm). Private collection.

Plate 3
Left to right
Buckle
Thomas Shields (American, Philadelphia, 1742–1819)
1780–90
Silver, length 1⅜" (3.5 cm)
Philadelphia Museum of Art. Gift of Mrs. Hampton L. Carson, 29-168-22

Cuff Links
Attributed to Richard Humphreys (American, Philadelphia)
1780–90
Silver and paste, length 1⅛" (2.9 cm)
Philadelphia Museum of Art. Gift of Gainor E. Roberts, 1979-17-13a,b

Clasp
Daniel Dupuy (American, Philadelphia, 1719–1807)
1770–1800
Gold, length 1" (2.5 cm)
Inscribed: L.E.R.
Philadelphia Museum of Art. Gift in memory of Elizabeth DuPuy Graham Hirst, 68-202-1

Buckle
Attributed to Richard Humphreys (American, Philadelphia)
1780–90
Silver and paste, width 1⅞" (4.8 cm)
Philadelphia Museum of Art. Gift of Gainor E. Roberts, 1979-17-12

Brooch
William Birch (American, born England, 1755-1834)
1820-25
Enamel on copper with gold frame, 1⅜ x 2³⁄₁₆" (3.5 x 5.6 cm)
Philadelphia Museum of Art. Purchased: Joseph E. Temple Fund, 12-104

Foreign travelers also penned their thoughts about Philadelphia. The Prince de Broglie commented on the curiously rigid customs in the home. He wrote about tea at Mrs. Robert Morris's:

I took some of the excellent tea, and would have taken more, I think, if the ambassador (M. de la Luzerne) had not kindly warned me at the twelfth cup that I must put my spoon across my cup when I wished to bring this warm-water question to an end. Said he, "It is almost as bad to refuse a cup of tea when it is offered to you as it would be for the master of the house to offer you another when the ceremony of the spoon has indicated your intentions on the subject."[16]

The 1790s was a period when these kinds of finicky gestures were practiced intensely. The Philadelphia grand dames such as Mrs. Morris or Mrs. Washington set the pace. Their customs may have been questioned or wondered at but were accepted until proved ridiculous, like some of the Binghams'. The salons' mixing of foreign dignitaries with the elected heads of the United States brought about a rigidity of social protocol in much the same way that the debates about the Constitution strengthened and stabilized the document. The Republican court, with Washington at its center, entered the complementary arenas of political and social action. Philadelphia emerged from this ten-year period of argument and exchange with a wider vision, ready for development and expansion.

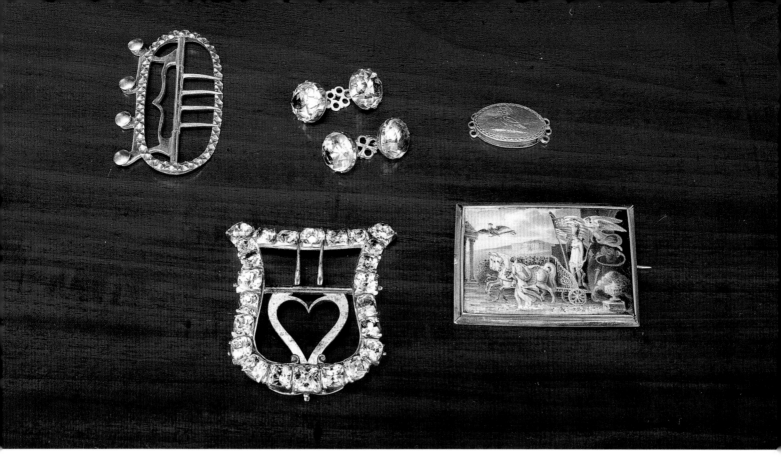

Jewelry

Rings, brooches, buckles, and occasionally necklaces are mentioned in Philadelphia wills and inventories, and there are frequent references to repairs in silversmiths' and goldsmiths' accounts. Silver was the most popular material for buckles. This example secured a belt made of ribbon or another soft textile and was fastened at one end with sewn or crocheted silk loops. The other end fitted through the buckle and was caught with the teeth. The X pattern stamped around the frame caught the light, suggesting diamonds. The softer metal gold was generally reserved for clasps, bracelets, earrings, necklaces—objects that served ornamental functions and light duty.

Gilbert Stuart's portrait of Frances Cadwalader Erskine (pl. 4) shows her wearing a simple buckle, while his of Anne Bingham (fig. 13) shows her considerably bedecked. Quakers in Philadelphia presumably wore some

personal jewelry. Richard Humphreys, one of Philadelphia's most prolific Quaker silversmiths, probably made the shield- and heart-shaped buckle and cuff links set with paste stones, which belonged to his wife, Hannah. Paste stones, made from a vitreous material, were a popular and acceptable substitute for precious gems. These were probably made in France from a formula developed about 1730 by Georges Frédéric Stras, who achieved a clarity and hardness that made the stones reflect like the best rock crystal.

The brooch, with its theme of the triumph of America or Liberty, was adapted from an engraving (fig. 36). It is a rare example of a personal ornament that made a public statement, not in the form of a medal or a society's badge, but of a shared sentiment of renewed patriotism after the War of 1812.

Courtly Portraiture

Plate 4
Gilbert Stuart (American, 1755–1828)
Portrait of Frances Cadwalader Erskine
1802
Oil on canvas, 28 x 23½" (71.1 x 59.7 cm)
Philadelphia Museum of Art. The Cad-
walader Collection. Purchased with funds
contributed by The Pew Memorial Trust,
and Gift of an anonymous donor,
1983-90-7

Gilbert Stuart's sensitive, subtle, and elegant portrait of Frances Cadwalader Erskine is an example of his courtly style at its best. He has caught his lively, sophisticated, and self-confident sitter in what must have been a rare moment of repose. Representatives of foreign governments were fêted constantly by the Republican court in Philadelphia as America strove for international recognition. Frances Cadwalader was one of the many Philadelphia women who chose mates from this pool of bright young men. As Peter Grotjan aptly observed, "It is a remarkable circumstance which I cannot omit to mention; that at this period amongst the wealthy citizens of our Seaport towns the rage to cultivate alliances with foreign noblemen, was so great, that our untitled native young men stood but a poor chance to gain the affections of the Stars of society."[17]

Frances Cadwalader was born and educated in Philadelphia, daughter of Gen. John Cadwalader and his second wife, Williamina Bond Cadwalader. In 1799 at Christ Church, Philadelphia, Frances married David Montague Erskine, who was at the time secretary to the British legation in Philadelphia. This portrait and its companion of her husband (Philadelphia Museum of Art) were painted in Philadelphia in 1802, just before Erskine was recalled to London. Although Stuart's portrait of Frances portrays her grace and ease, it misses entirely what must have been sparkling eyes, full of wit and challenge. Frances had written to her brother shortly after leaving Philadelphia in 1802, showing her good humor, "My *Husband* has been frolicking away at Brighton—dining five days running with the Prince & swallowing Champaign & Burgundy till his Face has got the true english hue if he had remain'd a little longer I tell him he

might have vied with his Host both as to size & colour."[18] The modest but elegant garb in which Stuart painted her belies the sense of fashion that Frances had. She even shared her knowledge with Dolley Madison: when both were in Washington, D.C., in 1806, Frances sent Mrs. Madison "the Corsets but my favorite pair are at present in the Wash. . . . I fear you will find nothing new in the shape of the Dresses which are very simple."[19]

From Erskine's various diplomatic posts, Frances kept in close touch with her relatives, writing gaily to her brother Thomas about her twelve children and the new baby. She entertained and was entertained in Washington, D.C., and throughout Europe, and she became well known for her energy and style. When in Washington in 1806, Frances wrote to Thomas Cadwalader about dinners at the president's and the Madisons'. One letter urging her brother to visit Washington reveals her most appealing quality, her bubbling mirth, which she shared with family and friends throughout her life; she wrote that Mr. Madison "became at last so facetious that he quizzed my long train and told me a Lady that he saw the other day had such an immense train that as the President was leading her out to dinner he thought from the enormous length it extended that it was by an accident tore from the body and was just running up very eagerly to let the Lady know what had happen'd when he discover'd his mistake. I knew the person alluded to was myself."[20]

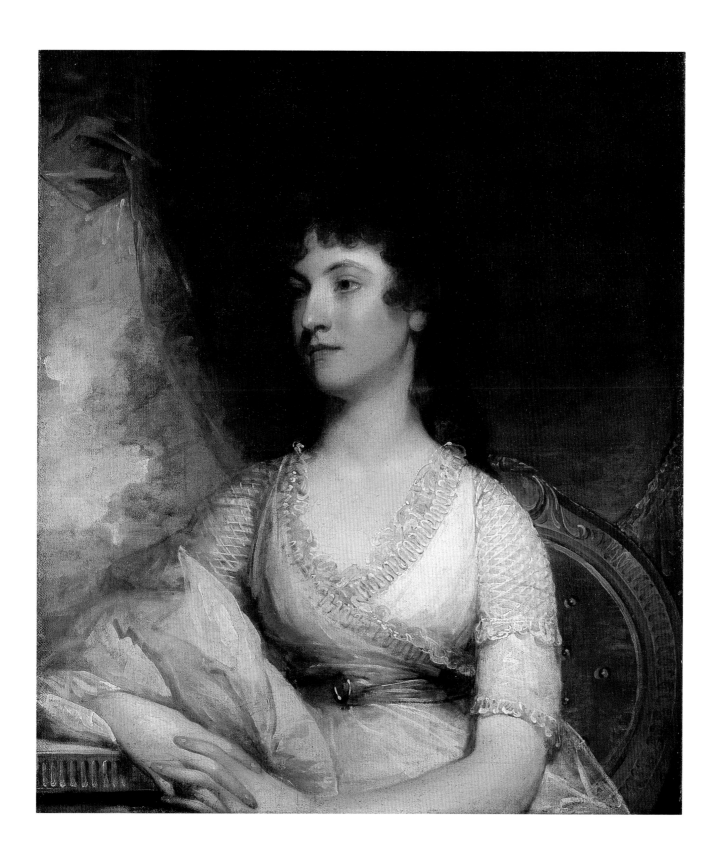

Painterly Touch

Plate 5
Thomas Sully (American, born England, 1783–1872)
Portrait of Maria Donath Koecker
1820
Oil on canvas, 33³⁄₄ x 27¹⁄₂″
(85.7 x 69.8 cm)
Philadelphia Museum of Art. Bequest of Leonora L. Koecker, 42-37-2

Thomas Sully painted this portrait of Maria Donath Koecker in 1820, a year after her marriage to Dr. Leonard Koecker, an established surgeon-dentist practicing at 174 Chestnut Street in 1818 and at York Row, on Walnut Street, in 1819. They were married on February 22, 1819. Her father, Joseph Donath; her brother, Joseph Jr.; and John Ruvert (Rouvert) signed as witnesses.[21] Sully painted another portrait of Maria Koecker in 1822, just before she moved to London, where her husband became the dentist to the future William IV.

Maria's father had gained some unusual notoriety during the Constitutional Convention. An importer of French glass, with offices at 28 South Front Street, he also ran a bee farm in Spring Mill during the summer. On July 22, 1787, he wrote in his small beekeeping journal, "This day General Washington, General Mifflin and four other members of the Convention did us the honor of paying us a visit, in order to see our vineyard and beehouses, in these they found great delight, made me a number of questions, and testified their highest approbation with my manner of managing bees, which gave me a great deal of pleasure."[22]

This portrait of Maria shows a spritely, alert person, whom Sully has portrayed in a fashionable dress and colorful silk shawl. The braids in her hair, probably her own, were worn in this period especially by women following central European custom. Sully approached his subject with his best painterly touch. He manipulated his full brush freely in his depiction of the textures of silk, ruffles, curls, leaves, and the terracotta vase. The composition has all the elements of the dramatic: the head is turned against the twist of the body, and there is a strong diagonal created by the sky and clouds. Maria's expression, in spite of her forthright gaze, is slightly dreamy and romantic, enhanced by Sully's polished style and the sitter's aplomb.

If there is any unresolved passage in this painting, it is the delineation of the sitter's right arm, which Sully has elongated beyond normal. John Neagle's report of a visit with Sully in London in 1827 suggests that Sully was still having trouble with foreshortening: "In conversation with Mr. Sully he says that *foreshortening* should never be attempted half-way—being better to give it a violent effect—either not foreshorten a limb at all, or very much—he observed that a finely drawn limb of the human figure ought to resemble a graceful flame."[23]

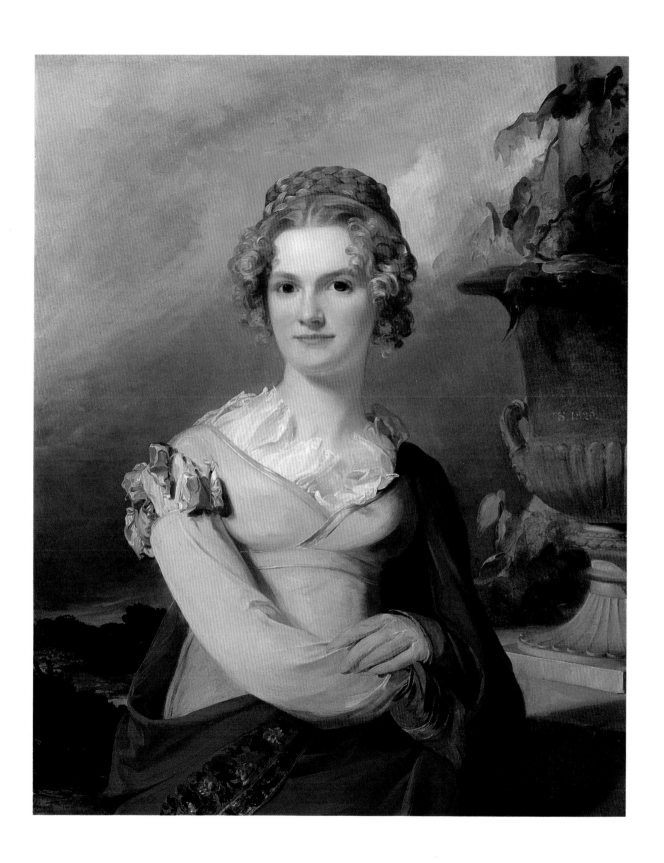

Lady's Writing Desk

Plate 6
Lady's Writing Desk
American, Philadelphia
c. 1801
Mahogany, satinwood, ivory, and inlaid
woods, with mirrors; height 59" (149.9 cm)
Philadelphia Museum of Art. Bequest of
Fanny Norris in memory of Louis Marie
Clapier, 40-46-2

In the Federal era, a period of growing specialization, dainty desks made expressly for women were new forms for new rooms. The writing desk might also have been a cabinet for jewelry, special books (certainly a diary), and fragile possessions such as feathers and ribbons and imported silk flowers. Made of mahogany and satinwood, with ivory, mirrors, and marquetry, this is an especially beautiful example of furniture made in Federal Philadelphia. This form might have been called a *bonheur-du-jour* or, as in Ackermann's *Repository of Arts* for March 1809, a "Ladies' Secretaire," an "elegant appendage to the drawing room or *boudoir*."[24] This example shows the most meticulous attention to detail, with fine, tight craftsmanship in the elaborate inlaid designs. The small cubbyhole at the interior's center is the heart of the design and, with its mirrored sides, must have been made to set off a fine, small personal ornament or sculptural object.

This desk belonged to Lewis Clapier's wife, Maria Heyle Clapier, whom he married in 1801. He was born in France, went to the West Indies, and settled in Philadelphia about 1796, where he invested in the French trade. He had fruitful trading connections all over the world and owned several ships, a town house at Sixth and Lombard streets, a trading establishment on South Front Street, and a country place near Nicetown; one of his cattle is the prize specimen portrayed in John Lewis Krimmel's *Parade of Victuallers* (see fig. 9). This desk descended to his daughter Dorothea, who married Charles Norris of Fairhill in January 1821, and was probably to be added to the ensemble in the newlyweds' house, which Deborah Logan described in her diary entry for April 26, 1822: "I heartily wish them every comfort and enjoyment. The house

. . . is richly furnished by the indulgent and Wealthy Parents of Dorothea."[25]

This desk bears a pencil inscription on the top of the base unit that reads: "Ce Meuble Reparé par Quervelle—May 8, 1822." The desk has not been attributed to the Philadelphia cabinetmaker Anthony G. Quervelle; the date of the noted repair and the lack of any major repairs suggest that this desk was sent off to Quervelle to be freshly polished for the Norrises' new house.

Stylistic similarities indicate that this small, graceful desk may have been made by William Sinclair. A desk with similar inlay patterns and details, including an ornamental center section also lined with mirrored glass and framed with columns, bears his trade card, dated 1803. His trade card has also been found glued inside a copy of *The Cabinet-Makers' Philadelphia and London Book of Prices*, published in 1796 at Philadelphia.[26] Sinclair worked first in Flourtown, a village in the Whitemarsh Valley on Bethlehem Pike. He married Catharine Kupp in Sellersville in September 1805. From September 1814 to January 1815, he served with the Pennsylvania Militia and was a member of Capt. James Sproat's company of the Germantown Blues. From 1818 to 1824, he was working at Hinckel's Court and at 9 Rachel Street, after which he returned to Flourtown, where he died in 1852, aged seventy-seven. This example of Philadelphia's interpretation of a French form—embodying a sophisticated design, the craftsman's skills, and supportive patronage—may have been designed directly from a plate in Thomas Sheraton's *Cabinet-Maker and Upholsterer's Drawing-Book* (3rd edition, 1802) or simply from the Philadelphia and London cabinetmakers' book of prices.

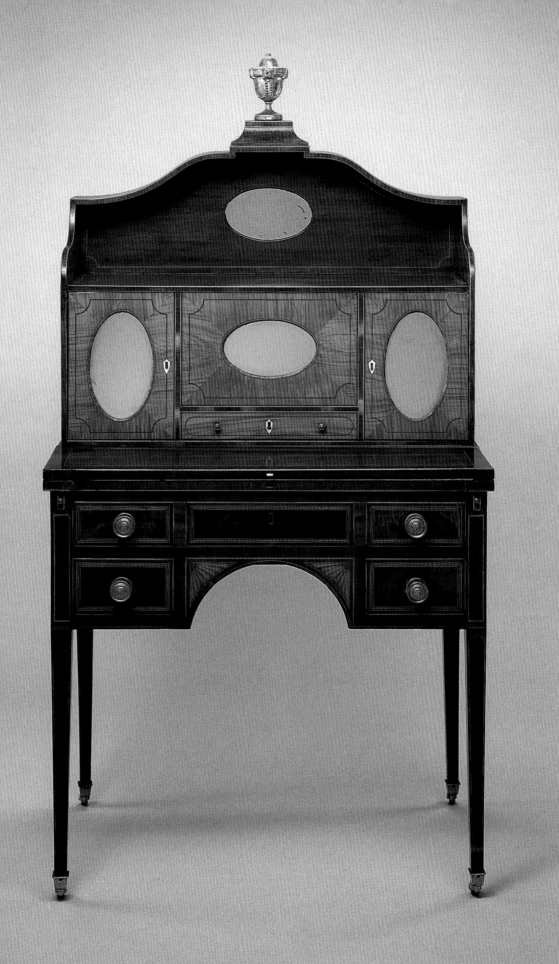

Sewing Table

Plate 7
Sewing Table
Possibly Michel Bouvier (American, born France, 1792–1874)
1815–20
Mahogany, maple, and brass; height 29³⁄₄" (75.6 cm)
Philadelphia Museum of Art. Bequest of Caroline D. Bache, 58-27-2

This table, a typical, conservative, and elegant adornment for a Philadelphia woman's morning room or a family parlor, was used to hold the equipment for sewing, or work, terms that were synonymous in 1800 and usually meant fancy needlework. A tambour frame sat on the top. England was the source for this new and specialized furniture form, and the earliest examples to appear in Philadelphia probably came through orders such as the one Joshua Gilpin placed in 1805 for a satinwood work table. Gilpin, like many Philadelphians, used the shipper Bainbridge Ansley & Co., a firm known for reliable packing. Gilpin also used the London cabinetmaker George Simson, who in 1806 billed him £15.15 for what must have been a surprise: "1 curious black rosewood and writing table for a lady with screen behind, cover'd with scarlet silk, top and sides lined with red morocco, brass mouldings on casters, silk bag etc."[27]

The Philadelphia cabinet shop that produced this lady's work table must have had a flurry of production, as there are many examples known that are almost exactly alike in size, profile, and ornament. The shop also made a number of card tables in the same vocabulary, and all show the same applied brass ornament ordered from Birmingham, England.[28] The basket-of-fruit handles are the largest of three sizes, model number 3642, as illustrated in a hardware catalogue at the Victoria and Albert Museum, each one costing 1s.6d. In the same catalogue number 4089 shows the swirling rosette, in prices from 1s.8d. to 2s.6d. The small dot-like circles are spikes that were sold by the dozen. The long horizontal brass mounts can be found in various hardware catalogues: the one on this table appears as number 10617 in an 1820 catalogue also at the Victoria and Albert Museum. Philadelphia newspaper advertisements did not describe specific brass mounts, although every issue advertised furniture hardware in great quantity. Philadelphia cabinetmakers had some direct access through London factors and could have ordered sizes and styles for particular uses. Newly emigrating cabinetmakers may also have brought batches of ornaments, which could explain why these whirling rosettes and spikes seem to be unique to the work of one cabinet shop.[29]

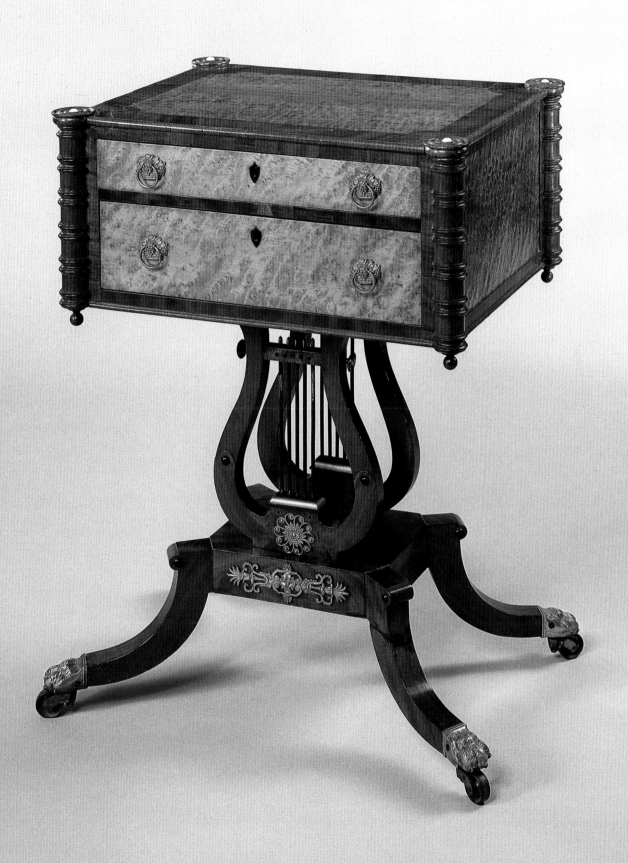

The Athens of the Western World

American eyes and ears were turned toward Philadelphia in the summer of 1787. The secret nature of the deliberations of the delegates to the Constitutional Convention had only heightened interest. When the great document was presented and was acclaimed by most of the concerned citizenry, Philadelphia once again basked in reflected glory. The Grand Federal Procession, staged in 1788 to mark ratification, was also national news. Under a cloudy sky but no rain, with a "brisk wind from the south," the bells of Christ Church greeted the dawn, and the cannon aboard the ship *Rising Sun* saluted the traditional Fourth of July celebration of independence. A great parade had been organized by a committee chaired by Francis Hopkinson, to celebrate "the Declaration of Independence . . . and the establishment of the Constitution or frame of government proposed by the late General Convention." All the ships in the harbor were dressed with flags, which were whipped into colorful display by the stiff breeze; ten ships bore large white banners at their mastheads inscribed in gold with the names of the ten states that had been ratified by that date. At 9:30 in the morning the parade commenced: military units, floats with everything aboard from buildings to potters at their wheels— in all, eighty-eight splendid groupings manned by Philadelphia organizations. The upholsterers' float was "headed by Messrs. John Mason and John Davis. In front a cushion, with its drapery, on which fluttered a dove with an olive-branch in its mouth, and on its head a double scroll. Motto, 'Be Liberty thine,' followed by a cabriole sofa decorated." The sugar refiners were led by seven men wearing "black cockades, blue sashes, and white aprons with a blue standard, arms on a gold field, the Cap of Liberty on a staff between two loaves of sugar. Motto, 'Double refined,' in a blue field, thirteen stars; crest, a lighted candle in a candlestick, on the foot the word 'Proof,' beneath 'American manufactures,' ornamented with sugar-canes; followed by thirty-six with white aprons, on which were painted sugar loaves." Hopkinson wrote on July 8, in his summary of the successful and orderly event, that some five thousand had lined the path of the parade, while seventeen thousand had gathered for the final moments and toasts on Union Green, near Fairmount. Tents with tables and food for all were set up with the ship *Union* as the centerpiece. Symbol of the day, the *Union* was later "moored" in front of the State House as a reminder of glorious events—independence in 1776 and the ratifying of the Constitution in 1788 (fig. 18).[1]

The newly formed Congress, concluding a short term in New York, voted in 1790 to move the seat of government to Philadelphia for ten years. With Philadelphia the capital, architecture, painting, crafts, fashion, science, engineering, and banking received new impetus in the capital city. Public amusements such as balloon ascensions and circuses,

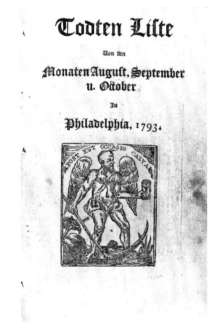

Figure 17
Cover of *Todten Liste von den Monaten August, September u. October in Philadelphia, 1793,* a booklet cataloguing deaths from yellow fever. Published by David Rittenhouse (American, Philadelphia, 1732–1796). Relief printed with letterpress, 6⅜ x 3¾" (16.2 x 9.5 cm). Philadelphia Museum of Art. Gift of Mrs. William D. Frishmuth, 03-331.

sideshows such as the animal oddities displayed at the Washington Museum, 48 Market Street, and all forms of theater throve. The climate of creativity nurtured inventions (such as the steamboat) and publishing enterprises (for example, Thomas Dobson's *Encyclopaedia; or, a Dictionary of Arts, Sciences, and Miscellaneous Literature*). Perhaps of more immediate significance were organized investigations into the causes of human diseases. Yellow fever, which killed about one sixth of Philadelphia's population in late summer 1793, forced the physician Benjamin Rush and the astronomer David Rittenhouse to analyze the source, spread, and treatment of the disease (see fig. 17).

Changing tastes in architecture were signaled in 1786 when William and Anne Bingham (fig. 13) returned from a two-year sojourn in London and the West Indies and built a grand town house in the regency style (fig. 19), based on drawings by London architect John Plaw. Set deep behind a high brick wall, the Bingham house was quite different from prewar Philadelphia architecture and caused considerable comment during construction. There was a large vestibule on the ground floor, from which a grand staircase curved upward to the principal rooms. The ornamented façade hinted at the rich interiors, which were furnished with brilliant silk curtains and French arabesque wallpaper in bright red, sky blue, yellow,

Figure 18
Ship "Union" before the State House, where this float was placed after the Grand Federal Procession. By J. P. Malcolm (English, born Philadelphia, 1767–1815), 1788. Watercolor on paper, 3³⁄₄ x 6⁷⁄₈" (9.5 x 17.5 cm). Collection of H. Richard Dietrich, Jr.

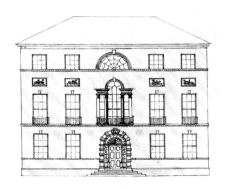

Figure 19
Bingham House, the first regency-style
house in Philadelphia. Drawn by Charles
Bulfinch (American, 1763–1844), 1789.
Ink on paper, 8⅜ x 10⅜" (21.3 x 26.3 cm).
Library of Congress, Washington, D.C.

and green. The interior doors were mirrored to increase the sparkle of crystal chandeliers. The final effect was fully appreciated by such knowledgeable visitors as the English antiquary Henry Wansey and the architect Charles Bulfinch, who visited Philadelphia in 1789, and was so impressed by the Bingham house that he not only drew its elevation (fig. 19) but also modeled many of his compositions in Boston after it. Yet the Bingham house, however grand its design, did not have much immediate influence on the architecture of its own city.

The homogeneity of Philadelphia's brick cityscape was celebrated. The great bank buildings of the late 1790s and early 1800s made a strong contrast to the domestic, brick façades, winning praise for style and execution. Three banks in particular asserted themselves as major architectural compositions: the Bank of the United States, on Third Street; the Bank of Pennsylvania, by Benjamin Henry Latrobe, on Second Street; and the Second Bank of the United States, by William Strickland, on Chestnut between Fourth and Fifth streets (figs. 20–24). Merchant Joshua Gilpin wrote to Benjamin West in London in 1803 about the changes he found in the cityscape upon his return to Philadelphia from abroad:

Our public buildings follow the public wealth; formerly in Rome the worship of the Gods was the ruling passion & temples tho not superb edifices, lately the God Plutus Has been the most propitious one to this City & we repay him in Temples, vulgarly called Banks. The Bank of the United States has a fine front of marble with a collonade of six well executed corinthian pillars, but the Bank of Pennsylvania is a beautiful, well proportioned & well executed building as any I saw in Europe. The body of it is a Cube of about 540 feet formed inside with a circular room lighted by a dome, & the two fronts which open to 2nd and Dock Streets are each noble porticos of the antient Ionic copied from the Temple of Minerva at Athens, the whole building is of beautiful marble, nearly white but with sufficient of a blue shade to prevent all glare, & the building is composed of very large blocks of stone some of them 20 feet in length, indeed nothing can exceed for such purposes, our Schuylkill quarries which furnish an exhaustless quantity of any size, cheaper than any other stone, so that we are fast becoming a City of Marble.[2]

The facades of these banks are supremely self-confident renditions of styles that must have echoed the confidence and optimism of Americans. The Bank of the United States was chartered on February 25, 1791. The design was probably drawn by Christopher Myers, a Dublin-trained draftsman who based his proposal on an appropriate prototype, Dublin's

Royal Exchange.[3] The bank building, erected 1795–97, was strikingly different from its Third Street neighbors, which were a typically mixed group: a tannery, several shops, and small houses. The bank displayed the full Corinthian order carved in white marble. Another Irishman, Claudius Le Grand, is credited with the work on the exterior. Recent conservation of a Corinthian capital from the interior, also attributed to Le Grand, has shown that, though made of mahogany, the capital was painted to imitate stone (fig. 21). Latrobe criticized the ambitious marble workmanship, but most Philadelphians thought it "an elegant exhibition of simple grandeur and chaste magnificence."[4]

Latrobe's design for the Bank of Pennsylvania, built 1799–1801, received acclaim as the model of Grecian architecture in America. Its style was smooth and monochromatic. Its details were subtle. The pattern made by the marble blocks on the sides (fig. 23) relieved the simple mass while allowing the three window openings full effect. Light flooded the interior through a lantern, which capped a low dome not obvious from either the front or the side. Latrobe must have known Sir John Soane's original architectural work on the Bank of England in London, begun in 1788.[5] In both buildings the architects made deliberate, almost pedantic reference to the classical vocabulary, achieving harmonious results similar to what some of their contemporaries were designing in France. The banks bore no evidence of Robert Adam's or the Palladian interpretation of classicism, both of which had dominated English and American architecture. Soane's bank and Latrobe's bank were the talk of their towns, and the ancient Greek style that characterized them became so successful that other historical styles were also studied and practiced: Italian Renaissance, Egyptian, and especially Gothic, which soon dominated English design.

While finishing up his Philadelphia commissions, Latrobe became an encouraging member of the city's newly formed art organizations. In 1811, busy with the capitol and the president's house in Washington, he addressed the Society of Artists of the United States, expressing his optimism about progress in Philadelphia. His learned address presented new ideas about patronage, leadership, and government in relation to art and architecture. He predicted that the ideals represented by the arts of the ancient world would continue, and that "the days of Greece may be revived in the woods of America, and Philadelphia become the Athens of the Western world."[6]

There is no question that Latrobe's most spectacular Philadelphia building, the Bank of Pennsylvania, was praised not only for its classical style but also for its embodiment of classical ideals, which by this time were firmly identified with the ideals of democracy. Its function as a

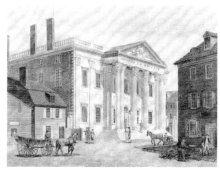

Figure 20
Bank of the United States, its neoclassical, marble façade in striking contrast to the surrounding structures. Drawn and engraved by William Birch (American, Philadelphia, 1755–1834), from *The City of Philadelphia* (Philadelphia, 1804). Hand-colored engraving, 8½ x 11¼" (21.6 x 28.3 cm). Philadelphia Museum of Art. Charles F. Williams Collection. Purchased, 23-23-227q.

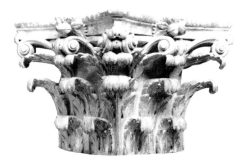

Figure 21
Capital from the interior of the Bank of the United States. Carved by Claudius Le Grand (American, born Ireland), 1795–97. Painted mahogany, height 17⁵⁄₁₆" (44 cm). Philadelphia Museum of Art. Gift of Thomas H. Marshall, 98-117.

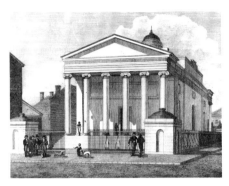

Figure 22
Bank of Pennsylvania, one of Benjamin
Henry Latrobe's major Philadelphia
buildings in the French neoclassical style.
Drawn and engraved by William Birch,
from *The City of Philadelphia.* Engraving,
12⅜ x 19¼" (31.4 x 48.9 cm).
Philadelphia Museum of Art. Purchased,
45-31-1.

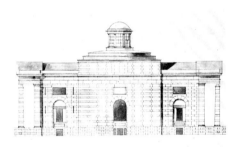

Figure 23
Side Elevation of the Bank of Pennsylvania,
showing the pattern formed by the mar-
ble blocks. Designed by Benjamin
Henry Latrobe (American, born England,
1764–1820), 1798. Graphite on paper,
13½ x 11¼" (34.3 x 28.6 cm). The
Historical Society of Pennsylvania,
Philadelphia.

bank, built to secure the new American currency and to encourage the
accumulation of wealth, only added to its importance, because at this
stage in America—and especially in Philadelphia, where so much of the
national government's business was conducted—there was a desperate
need for secure financial institutions. The bank and its purposes were
applauded.

The new patrons of architecture were young men launching profes-
sional careers. William Waln, Edward Shippen Burd, John Markoe, and
Joshua Gilpin, to name a few, were dependent upon ideas imported in
design books, ideas shaped by their reading in the classics and by archi-
tects, cabinetmakers, and silversmiths who in many cases had been
trained abroad and were fully able to execute the new styles. Their skill
could make the difference between an elegant, well-designed object and
an assemblage of isolated motifs that were supposed to be stylish. The
painters George Bridport and John Joseph Holland came to Philadelphia
from London; cabinetmaker Joseph Barry from Ireland via London;
cabinetmaker John Aitken from Scotland; silversmith Anthony Rasch
from Passau, Bavaria; and silversmith Simon Chaudron from France via
Santo Domingo. Houses, furniture, and silver were commissioned in
styles that had their source not only in the familiar English vocabulary but
also in the latest French taste, which arrived with European craftsmen and
in books such as Charles Percier's and P.F.L. Fontaine's collections of
ornamental designs. Latrobe, who was trained in England, knew the
European neoclassical styles well and was able to present potential clients
with books of his plans and details. He was as concerned about the
interior as the exterior of a building, and when employed by Waln and
Markoe, he designed their furniture as well.

But the Philadelphia architects who imitated Latrobe's classical refer-
ences seemed to miss the subtlety of his interpretations using French
design. Often they were following the dictates of world travelers such as
Philadelphia financier Nicholas Biddle, patrons who sought only the
purest Greek designs. In the Second Bank of the United States, Strick-
land followed this fashion and created a temple on Chestnut Street. His
design for the handsome, bold building won a competition in 1818, and
the bank was completed in 1824. Although Latrobe was by this time
concentrating on commissions in Washington, D.C., he also submitted a
design for the bank.

Latrobe's French classicism had added a distinguished element to the
fabric of Federal Philadelphia. It was eclipsed, however, by the prolifera-
tion of pure temple forms such as the Second Bank and Founder's Hall of
Girard College, partially classical porticoes such as that of Strickland's
United States Naval Asylum and the gatehouse of Laurel Hill Cemetery,

and Greek motifs simply applied as ornament to decorative art. After 1825 classical meant Greek, and Greek revival became America's first national style.

While Latrobe and Strickland were designing for adventuresome Philadelphians ready to build what must have seemed experimental architecture to the more traditional public, changes in other areas were affecting life within even the most conservative households. As the city expanded westward along Chestnut, Walnut, Locust, and Market streets, and as the work force changed in their origins and methods, the functions of houses changed, and public buildings became focal points of more activities. Bankers and lawyers went to workplaces outside their homes that were more convenient than the old, dockside countinghouses. Changes in the use of space within the home was the result. The office of a lawyer, doctor, or merchant previously would have been a small room on the first floor of the house, with access to the street. But at the turn of the century, the tall, double-entry ledgers began to move out of the home, along with the tall secretary bookcases that housed them, and the rooms they left were turned into so-called morning parlors. These supplemented the existing parlors, which were reserved for more formal functions, and families gathered there in the evening for reading. The young preferred novels to sermons, though diaries record plenty of both. The morning parlors were furnished with ladies' writing desks, worktables for sewing, bookcases, multipurpose drop-leaf tables, and sets of cushioned or upholstered chairs. Parlors were not considered furnished unless fitted out with a carpet instead of the serviceable, painted floorcloth. Other rooms also began to be devoted to special purposes. Whereas halls and chambers had been deemed perfectly suitable for dining earlier in the eighteenth century, in the Federal period the custom of serving long, formal dinners demanded large rooms set aside specifically for dining and furnished with extension tables, dozens of chairs, sideboards, and other trappings designed to satisfy demand.

With a spurt of growth in the population during the 1790s, improvements were needed in roads, bridges, and canals. Such major civic projects made important changes in Philadelphia life, urban and rural. Clean water was an ongoing concern. Latrobe, trained as an engineer as well as an architect, persuaded the city fathers to let him design a system to supply the city with running water from the Schuylkill River. In spite of some misfires and tiresome nipping at his heels by Thomas Cope, one of the managers of the project, Latrobe completed the job, and Cope admitted in his diary entry for June 1, 1804, "The citizens have become so fond of the Schuylkill water. It is found to be so much more pure than the water from the pumps, so necessary to the proper cleansing of the gutters

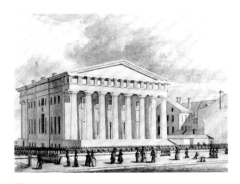

Figure 24
Second Bank of the United States, designed by William Strickland in the Greek revival style. Drawn by George Strickland (American), c. 1825. Watercolor and ink on paper, 6⅜ x 7¼" (16.2 x 18.4 cm). The Library Company of Philadelphia.

Figure 25
Market Street Bridge, also known as the Permanent Bridge, seen from the southwest bank of the Schuylkill River. Painted by John J. Barralet (Irish, died America, 1747–1815), c. 1810. Oil on canvas, 36 x 48″ (91.4 x 121.9 cm). The Historical Society of Pennsylvania, Philadelphia.

& streets & so important in times of fire that to deprive them of it now would occasion abundantly more clamour than was raised at its introduction." He also described the public's reaction to the pump house Latrobe designed for the city's Centre Square: "Many also objected to the circular form given to the Centre Square & to the erection of the House in the middle of it who are now highly pleased with both. The shady walks already afford a refreshing retreat."[7] Latrobe's design added a porch to a cylindrical form perhaps inspired by the sepulcher of Hadrian at Rome (A.D. c. 138), creating a tiny building of great dignity that, like the waterworks at Fairmount, became one of the popular local subjects for artists in the early nineteenth century.

Another important and much-praised project was the Permanent Bridge (fig. 25), which crossed the Schuylkill at Market Street and offered for the first time year-round conveyance above the river's unpredictable freshets. This and later bridges over the Schuylkill made the west shore's country estates, in this period called villas, readily accessible for summer rental, picnicking, and casual visiting. Many diarists mention going to the banks of the Schuylkill for recreation. William Meredith "walked with Dunlap all the Afternoon, up the Schuylkill took a Boat & went in to swim—A sweet & beautiful river, above the Upper Ferry."[8] In 1804 Thomas Cope made

a family visit to the elegant seat of William Hamilton [Woodlands] *near Gray's* [Ferry] *on the west bank of the Schuylkill* [fig. 26]. *It is a place of much public resort, owing to his having that rare curiosity—an Aloe in bloom. . . . Hamilton's garden is the best furnished of any in the vicinity of Philada., with rare plants both domestic & exotic . . . and the gardner observes of them that they have not yet become naturalized to our climate but, as the seasons of their native country are opposite to ours, these plants continue to vegetate & flower in winter & to decay in the summer.*[9]

Harriet Manigault wrote in 1815: "We have been lately to see several country places on the Schuylkill escorted by the Judge. The one we liked best was a place belonging to Mr. Rawle [Laurel Hill]. Charlotte and I went the other afternoon to Mr. Pratt's place [Lemon Hill] with Mde de Kantzow, where we were very much pleased."[10]

The grounds of Lemon Hill, on the east side of the Schuylkill, were semipublic: visitors wandered the extensive gardens freely. Like Woodlands, Lemon Hill had greenhouses (fig. 27). Henry Pratt, who built the mansion in 1799, added to the greenhouses that Robert Morris, the property's previous owner, had had in operation by 1789. Lemon Hill is a handsome house in the Adam style, with smooth, stucco exterior sur-

faces; a projecting oval bay; floor-to-ceiling windows; and a spiral staircase. The interior spaces are light and elegant, but the steep exterior staircase up to the entrance shows none of Latrobe's suave style. Nor does the house resemble its neighbors, such as Ormiston, Rockland, and Strawberry Mansion, all villas built between 1798 and 1805 on the east shore of the Schuylkill. Lemon Hill is instead much closer architecturally to the austere work of Bulfinch in New England.

Although Lemon Hill was probably designed for Pratt by an architect, most of the neighboring villas were designed by their owners, whose plans were brought to fruition by competent master carpenters. Edward Shippen Burd's carpenter at Ormiston was Robert Jackson, who also erected for Burd a town house probably designed by Robert Mills, Latrobe's assistant in Philadelphia. In 1799 Ormiston was a typical, if small, three-bay house, with smooth stucco surface, plain window frames, and a shallow porch supported by four Doric columns. It shows the typical Philadelphia mixture of Federal detailing in the woodwork and plasterwork with the more sophisticated spacing of Adam-style neoclassicism. As an indication of the extent of plasterwork, Burd's plasterer, John Johnson, was paid £201 out of a total building expenditure of £2,581.4.6. He also ordered a great deal of prefabricated composition ornament from George Andrews.[11] Such ornament was readily available in almost any size, motif, or form, including running beads and banding; like true plasterwork, it was used on overdoors, ceilings, fireplace surrounds, and cornices.

Typical of the residents of the riverside villas, Burd moved his entire household to and fro in spring and fall, making a pleasant horseback ride into town to the office when necessary. There did not seem to be any sense that the country residents were isolated from either action or news. Some were commuters like William Page, a merchant who lived in Germantown and kept a store on Chestnut Street. He wrote a casual diary, noting that he occasionally played loo or "Vingt un" with his friends in the city before walking or riding home.[12] At Stenton Deborah Norris Logan, living five miles out, wrote in 1821:

Yesterday there was no company and the family but small, being attracted to the city to see a marvelously foolish show made by White the Butcher, who having purchased many fat Cattle of our neighbor Clapier and others, to which he added venison and Bear meat, was desirous of procuring a sale for it by exciting Public notice, and it was surprising to see how the people flocked in from the country round, (and even from above 30 & 40 miles) to see the exhibition. It was fairly a Public holyday [see fig. 9].[13]

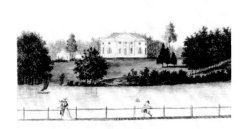

Figure 26
Woodlands, the Seat of W. Hamilton Esq., from the Bridge at Gray's Ferry. Drawn by J. P. Malcolm, 1792–94. Watercolor on paper, 4 x 6⅜" (10.2 x 16.2 cm). Collection of H. Richard Dietrich, Jr.

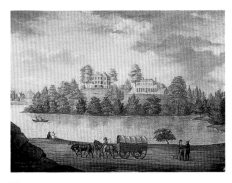

Figure 27
Lemon Hill, with a large greenhouse at right. Painted by John A. Woodside (American, Philadelphia, 1781–1852), 1807. Oil on canvas, 20⅜ x 26⅝" (51.7 x 67.6 cm). The Historical Society of Pennsylvania, Philadelphia.

There was plenty of news in the daily press about happenings in Philadelphia. For example, in 1786 a huge crowd witnessed the sale of the *Alliance,* the frigate sailed by John Paul Jones and then Commodore Barry. Robert Morris bought it, and it became the second ship to sail from Philadelphia in the China trade. Saint Tammany's Day, which commemorated a seventeenth-century chief of the Lenape, was always colorful. The revelers met on May 12 near the Schuylkill. Politicians often met at Oellers' Hotel, as did the Pennsylvania Society for the Encouragement of Manufactures of the Useful Arts.

During the Federal period the Quakers continued their old social customs. They were not diverted by the antics of the society run by Washingtons, Binghams, and Morrises. Quakers exchanged family visits in the morning, in the afternoon for dinner and tea, or overnight; they would drop in with no special invitations or warnings to the hostess. They took an interest also in civic projects and events. The Logans entertained such dignitaries as Thomas Jefferson and Joseph Bonaparte. Deborah Logan's diary describes her visit to Samuel Humphreys's shipyard to see the USS *Franklin* (fig. 28) in August 1815: "Then we went down to the Navy Yard to see the new 74 which is building and which is named 'The Franklin,' his Head is a good likeness; by the politeness of the midshipman we were shewn the Frigate, I mounted up the ascent and went in at a Porthole, and up & down the strait stairs between decks. . . . I cannot say that my mind was quite satisfied with the propriety of an old Quaker Lady's going on board of the Frigate."[14]

The work ethic established by Penn's Quakers and reinforced by Franklin's maxims encouraged civic participation and voluntarism

throughout the city. No matter how busy the docks, the banks, or the workshops, Philadelphians were active in the development of their city and of the institutions and services that they hoped would guarantee peace and harmony to the most people. The many fire companies depended on volunteer staffs, and the plaques given out by insurance companies to indicate coverage in case of fire (fig. 29) are still hung on city houses. Organizations were founded also to ease the adjustment of recently arrived Europeans. A German masonic chapter, Hermann was established in Philadelphia in 1810 partly with the idea of keeping Germanic traditions and language alive in this country. The Philadelphia chapter still meets regularly. An elegant, veneered coffer with ivory feet, inscribed and dated 1816 (fig. 30), may have been made for their grand master.

After the War of 1812, as the federal government at last became firmly established in Washington, D.C., Philadelphia concentrated again on the sponsorship of technology and the arts. Like New Yorkers, Philadelphians invested in the numerous canals under construction, linking eastern cities to western farms. The Franklin Institute and the Academy of Natural Sciences promoted scientific education and research; the Pennsylvania Academy of the Fine Arts carried on its classes and exhibitions. Such institutions kept alive the optimism and pride spawned by Philadelphia's hosting the Constitutional Convention and the new government, and their supporters continued the pursuits that had made Philadelphia the Athens of the western world.

Figure 30
Coffer possibly made for the grand master of Hermann, a German masonic chapter in Philadelphia. Engraved by J. Bowen (American, Philadelphia), 1816. Mahogany, maple, tulipwood, ivory, and brass; height 16¼″ (41.3 cm). Inscribed: Die Hermann Interstutzungs Brunderschafft / PHILADᴬ / J. Bowen Sc. / Incorporirt den 1 sten May / IMJAHR / 1816. Yale University Art Gallery, New Haven.

Plate 8
Mantel, shown with garniture, clock, and fireplace tools
American, Philadelphia
1790–1815
Painted pine, mahogany, and composition ornament; 58$\frac{1}{2}$ x 78$\frac{3}{4}$" (148.6 x 200 cm)
Philadelphia Museum of Art.
Purchased: Joseph E. Temple Fund, 10-408

The mantel and its accessories—brass and iron andirons, tongs and a shovel in their jamb hooks, an iron fireback, and a protective fender—were the focal point in most Federal Philadelphia rooms. In the summer the unused fireplace was covered with a decoratively painted or wallpaper-covered board,[15] perhaps similar to better-known New England examples. A garniture, a clock, and possibly family memorabilia on the mantelshelf completed the design, carrying upward the lines of the pilasters and the central plinth.

Elaborate mantels like this one exhibit the gusto with which Philadelphia woodworkers went at their tasks, a gusto captured also by their rallying song "The Raising: A New Song for Federal Mechanics." Published in the *Pennsylvania Gazette* on February 6, 1788, it opens with a fitting introduction to Philadelphia woodwork in the Federal era: "Come muster, my Lads, your mechanical Tools/Your Saws and your Axes, your Hammers and Rules/Bring your Mallets and Planes, your Level and Line/And plenty of Pins of American Pine." In this period, though neither the gouge nor the punch were new tools, Philadelphia carpenters put them to use with a vengeance on fireplace surrounds. Rarely were two mantels alike. Many designers, however, disapproved of such flamboyance. Benjamin Henry Latrobe described the mantels of Philadelphia craftsmen as "all spindle shanked, gouty legged, jewelled, dropsical, crysypaglatic, hydro-cephalic columns"[16]—in short there were two schools of design in the period, the carpenter's fancy and Latrobe plain. Likewise, Owen Biddle, in his *Young Carpenter's Assistant* (1805), advised restraint: "In ornamenting a mantel the young carpenter would do well to endeavour at an imitation of something

natural, and not to cover his work with unmeaning holes and cuttings of a gouge."[17]

Yet even when the carving is as elaborate as on this example, it blends all the better with the molded and applied composition ornament. Probably the carpenters themselves went to the composition-ornament suppliers for the extra embellishments. Robert Wellford, who kept a shop in Philadelphia throughout the first quarter of the nineteenth century, was a leading manufacturer of the material. The units of composition ornament he created would be dampened slightly, warmed, and then applied to woodwork with glue. Philadelphia plasterers, who worked in a related craft, also did a thriving business during the Federal period. From a rare volume of plasterers' accounts, some idea of interior ornament can be gained. For example, when William Jones did the plasterwork at Henry Pratt's new house on Fourth Street in 1812, Jones charged for a ten-inch rosette, presumably a central ceiling ornament; "4 rosettes in the center pannel entry"; ornamental work over the folding door of the front parlor and over the large door of the same room; eight seven-inch blocks and rosettes; one nine-inch rosette; and "sixteen small blocks and patteraes."Most patterns used in Philadelphia were custom-made here, and any design could be ordered, from a Liberty head to rows of "seed."[18] Plaster ornaments were most often used on ceilings and friezes, applied to the wet plaster coating. All the ornament in a Federal-style room—punch and gouge carving, composition and plaster ornament—had the same low-relief character, and it was given a final, unifying touch with two coats of paint.

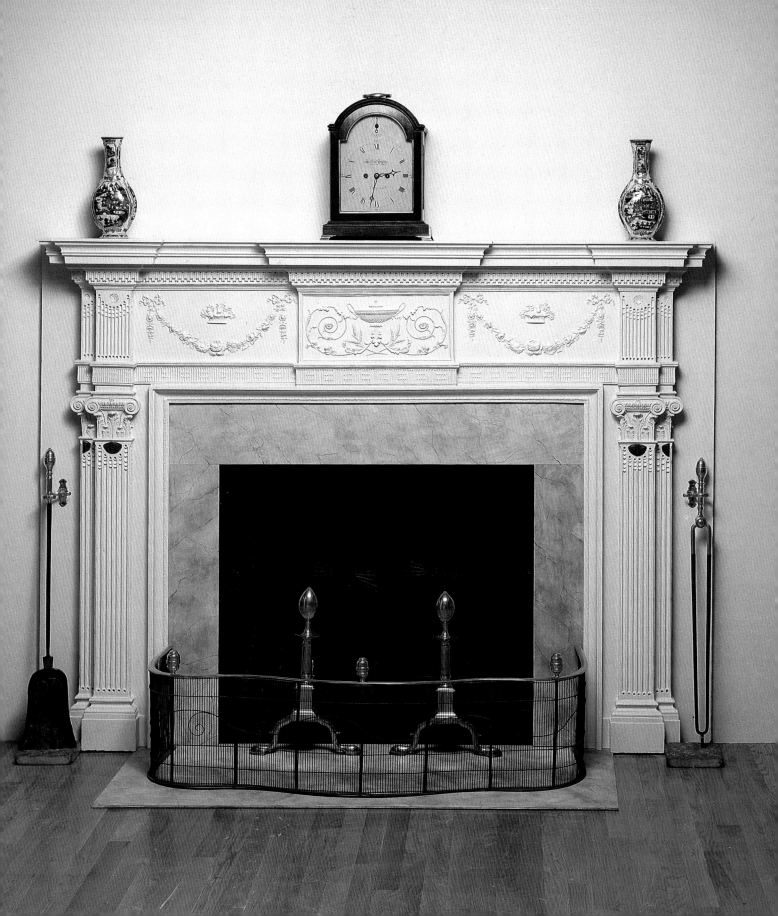

Plate 9
Bookcase
Attributed to John Aitken (American,
born Scotland, active c. 1790–1814)
1780–1800
Mahogany, maple, tulipwood, and glass;
height 92″ (233.7 cm)
Philadelphia Museum of Art. Gift of
R. Wistar Harvey, 40-16-21

Part of the Library of Robert Waln.
Library of the Philadelphia Museum of
Art. Gift of Mr. and Mrs. R. Alexander
Montgomery

Philadelphians were great readers. Bills, receipts, and inventories reveal that most families, almost regardless of their station in life, owned books. Young William Meredith's diary, which he wrote between 1817 and 1821, notes almost daily that he "read in Binney" or "read in Cicero de Inventione."[19] Young men routinely had access to their fathers' books, but young women approached them with trepidation. Harriet Manigault wrote on September 12, 1814, "Mama & my Aunt played at piquet, and after I had [done needlework] for some time, I bethought me of my Uncles library, & after considering for some time, I took courage and went into it, as I knew there were books there, that were not meant for ladies and I did not hesitate but took a volume of Socrates, found it most entertaining. I should like to read it through, but then they say that it gives one false ideas etc."[20]

In this bookcase is part of the library collected in the late eighteenth and early nineteenth centuries by Robert Waln, a merchant who wrote several books himself.[21] He was a prosperous merchant in the China trade and a Quaker, which may account for the great number of sermons and tracts in his collection.

The well-dressed morning parlor was expected to contain books, and they in turn required a handsome storage case. In form and decoration this grand bookcase, attributed to John Aitken, is in the tradition of late eighteenth-century English cabinetry. The balloon pattern of the muntins in the upper doors and the elliptical, veneer panels set into the almost square doors below are features adopted in Philadelphia from imported English furniture and from George Hepplewhite's designs in *The Cabinet-Maker and Upholsterer's Guide* (1788). The bookcase has features in common with two other

pieces ascribed to Aitken: a secretary desk (now at Mount Vernon) ordered by George Washington and a lady's writing desk (private collection) inscribed "John Aitken / cabinetmaker / No. 79 Dock Street Philadelphia." The three pieces have similar muntin patterns, banding of maple outlining the muntins, cross-grained veneer on the margins of the doors and at the cornices, small escutcheons, and highly figured mahogany veneer of uniform thickness and color.

Beneath the veneer the framework of the bookcase is traditional. Two broad panels at each end are set into a joined frame; the corners of the feet are dovetailed; and the lower doors use bread-board construction, one large panel let into a board at each end. The doors are veneered also on the top edges. The sturdy character of the construction confirms the late eighteenth-century date suggested by the bookcase's design, as does the inlaid eagle displaying thirteen stars, which was the number of states until 1795.

John Aitken, a Scot, was in Philadelphia by 1790, when he advertised in the *Federal Gazette* on June 9, "He still carries on the cabinet and chair manufactory where he has for sale, chairs of various patterns. . . . Likewise desks, bureaus, book cases, bed steads, tea tables, card ditto, dining ditto etc."[22] Aitken was considered by his peers to be a premier cabinetmaker and was a major employer in the trade by 1794.

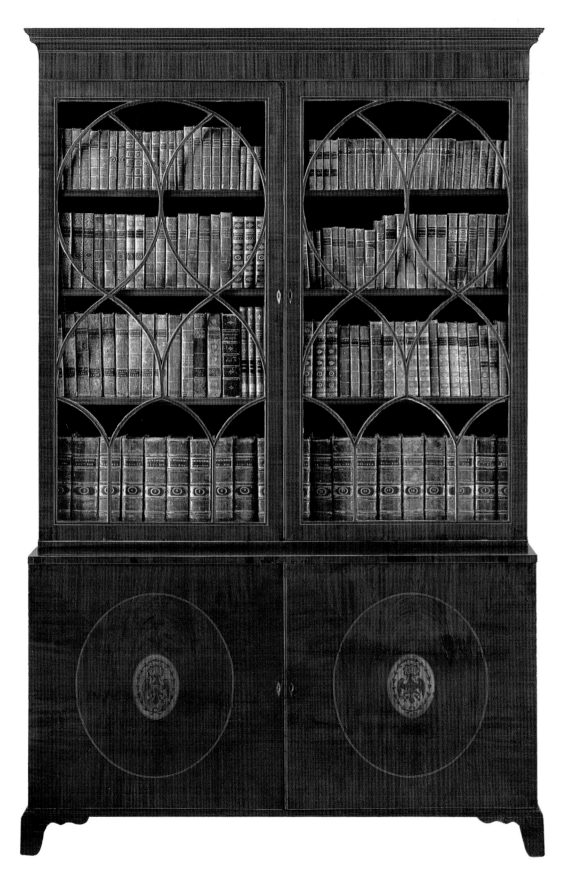

Calico Printing

John Hewson, who printed this coverlet, was probably the most prominent practitioner of calico printing in Philadelphia, for he was the main representative of the craft in the Grand Federal Procession of 1788. He was very successful at his trade, a good example of the craftsmen who resumed their work with more capital investment and with increasing markets after the Revolution. Hewson was trained at the Bromley Hall printing works, in London. He established a factory at Kensington, just north of Philadelphia's limits, before the Revolution, but the works were destroyed while he was serving in the Philadelphia militia. After the war he took on a partner, also trained in England, and in 1789 the firm won a gold medal from the Pennsylvania Society for the Encouragement of Manufactures of the Useful Arts for submitting "the best specimen of calico printing done in the State."[23]

Calico printing, like most trades, required specialized equipment, which meant capital investment. Hewson's estate papers list the equipment he left to his son John to carry on, including printing tables, blankets, mauls, copper boilers and kettles, screw presses. Hewson's long will lists further evidence of his prosperity: items of silver, fine furnishings, looking glasses, Windsor chairs painted white and black, and so on. He was still more specific about the personal effects that his son was to receive, such as Hewson's gold medal, and family Bible.[24]

Ceremonial Silver

This rare survival of ceremonial paraphernalia was probably commissioned for a parade, investiture, or meeting-room color guard. It fitted on the end of a tapered pole to which was fastened a flag. Amable Brasier, who engraved his name and "Philada." on the head, may have made this ornament, although it does not bear his punch mark. Brasier was a French Catholic artisan who first appeared in Philadelphia records as a watchmaker-jeweler, not a silversmith. This may have been an item in his stock that he signed as a presentation piece for a friend or an organization. He lived at 23 North Third Street until 1811, then at 12 South Third, and from 1833 at 117 South Third.

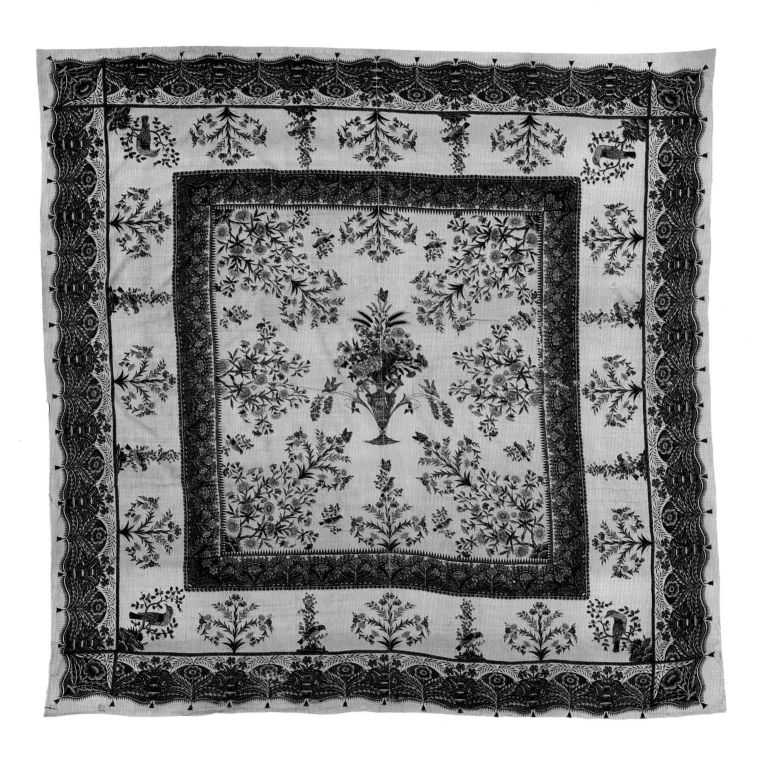

Plate 12
Table
Attributed to Henry Connelly (American, Philadelphia, 1770–1826)
1800–1810
Mahogany, 28 x 48″ (71.1 x 121.9 cm)
Philadelphia Museum of Art. Bequest of Henry P. McIlhenny, 1986-317-016

This table is one of several that are almost exactly alike, including their carving, and that vary only in size. They have been attributed to Henry Connelly, a cabinetmaker with a large shop at 72 and 74 South Fourth Street. Attribution to Connelly can only be conjectural, for a sideboard bearing his label is also inscribed clearly in pencil, "Robert McGuffin / Maker/1806" (Philadelphia Museum of Art). Likewise, a sofa long attributed to Connelly is inscribed, "Samuel McIntire" (private collection). McGuffin and McIntire are listed at various addresses in the Philadelphia directories. They were perhaps among the workmen in Connelly's shop, whose staff consisted of both journeymen and apprentices doing piecework on special order and for stock.

By 1796, when *The Cabinet-Makers' Philadelphia and London Book of Prices* was published in Philadelphia, most cabinetmaking shops were paying their workers according to the pricing systems recorded in this and similar books. For example, in the 1796 Philadelphia price book a plain table of the size shown here, described as "a pillar-and-claw dining table," cost nine shillings in labor; each fly, or drop leaf, cost one additional shilling. Further additions, such as carving on the legs, veneer on the frame and drawer fronts, or rounded corners on the drop leaves, added considerably to the cost.[25] This table appears to be the work of a skilled hand and a sophisticated eye, representing Philadelphia's suave adaptation of London's regency fashion.

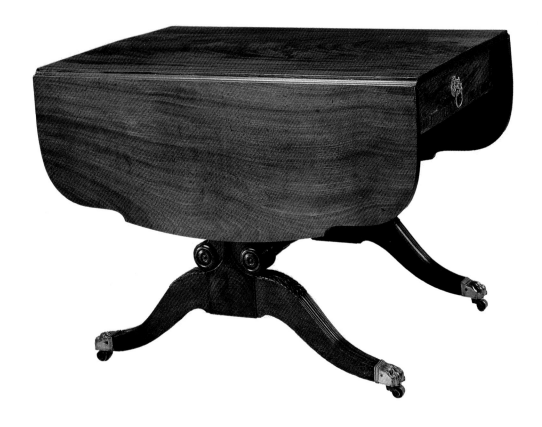

Dining Rooms

The attitudes and rituals associated with dining and entertaining changed drastically in the Federal period from the seemingly casual, drop-in style that Deborah Logan described in her diary. Almost immediately after the war, probably encouraged by the political protocol that was developing in America, dining became ceremony, and ceremony requires paraphernalia. Instead of separate tables, one large table and a large set of chairs to seat all the guests were required. When not in use, the chairs were lined up against the walls, where the repetitive pattern of the tracery in the chair backs complimented the delicate patterns in the wallpaper and the composition ornament applied to woodwork. Red silk and black horsehair were favored textiles for upholstery.

The sideboard with cabinets and drawers was introduced with the new dining customs. It held all the equipment for several course settings and displayed the family silver and porcelain; pullout slides at each end of this example could expand its capacity for service. This sideboard disassembles into five units in order to facilitate moving, perhaps up steep stairs to a second-floor dining room. Joseph Barry was one cabinetmaker who is known to have made case furniture in this manner, to be shipped in the coastal trade. Furniture attributed to Barry shows a reliance upon the English design book *Collection of Designs for Household Furniture and Interior Decoration* (1808), by George Smith, although some of the exotic charm of Smith's designs is absent.

Plate 13
Sideboard
Attributed to Joseph Barry (American, born Ireland, 1757?–1839)
1815–20
Mahogany and pine, height 40⅝″ (103.2 cm)
Philadelphia Museum of Art. Gift of the estate of Estelle C. Mebus, 1983-77-1

Vive la France

Figure 31
Bust of the Marquis de Lafayette, by
William Rush (American, Philadelphia,
1756–1833), 1824. Terra cotta, height
21¹⁵⁄₁₆″ (55.7 cm). The Pennsylvania
Academy of the Fine Arts. Gift of
Dr. Wm. Rush Denton, Jr.

Lafayette was the spark that ignited Philadelphia's passion for France (fig. 31). In 1777, age nineteen, he arrived to join up with the American troops in their fight for independence from Great Britain. His family was wealthy and influential, and from the start young Lafayette was trusted and given responsible military and diplomatic positions. He lived up to such demands and became a hero to Americans. Later, in 1790, Jefferson wrote to William Short in Paris: "My pictures of American worthies will be absolutely incomplete till I get the M. de la fayette's. Tell him this, and that he must permit you to have it drawn for me."[1]

After the war Lafayette continued to be an important political contact with France, and his imprisonment during the French Revolution added to his personal stature in America. When he returned to America in 1824, the last of the major surviving revolutionary figures, Americans staged enormous celebrations in his honor, north and south. His triumphal reentry onto the American stage evoked nostalgia in the generation that had fought in the war.

After the disruptions of the American and French revolutions and the War of 1812 had subsided, during the peaceful era of the early nineteenth century, when the populace could attend to ideals rather than strife, French influence took the form of an obsession with style. The fundamentals of the designs collectively known today as the Empire style had been disseminated years earlier in Philadelphia by Benjamin Henry Latrobe from French and English design books. Now, however, his subtle balance of form and ornament was thrown off by the weight of fad. French fashion in everything from furniture (see fig. 32) to umbrellas was copied, and decorative motifs began to have a life of their own, losing their identity with form. By the time Lafayette said his final farewells, the Empire style, also known as Greek revival, was firmly established in Philadelphia and nationally.

There had been few French settlers in Pennsylvania before the Revolutionary War beside those from the German-speaking eastern regions of France, the farms and towns along the Rhine in Alsace. They had come to Pennsylvania as refugees from persecutions after the revocation of the Edict of Nantes, in 1685, and had become part of the "Pennsylvania Dutch" settlements. But between 1785 and 1825 two events in France particularly affected Philadelphia: the revolution, beginning in 1789, and the overthrow of Napoleon in 1815. At both times émigrés fled to safety in America, and especially to Philadelphia, which was reputed to be the most cosmopolitan city that also welcomed distressed Europeans. Escaping aristocrats and royalists, along with craftsmen and merchants looking for more secure patronage and trade, came in the first wave. In the second group the Bonaparte family and their entourage were of

most significance. Both groups left their imprint on Philadelphia life, politics, and art.

Americans had looked to France, to Paris and the royal court, for support in the war against Great Britain, and French involvement, which alleviated a desperate military situation in 1780–81, had been the deciding factor in the American victory at Yorktown. Benjamin Franklin, in his role as ambassador from America—not yet the United States—might have arrived as just another suppliant at the French court, but his intellect and wit soon won enough influence to open doors not only to the salons, where he was an immediate favorite, but also to the power centers of France. The elderly Franklin won French hearts as the youthful Lafayette won American hearts. Strong bonds between the two nations were established by the creative energies of these two men.

There was a good deal of ambiguity in Philadelphia about the politics of France. On the one hand, everyone was thankful for the support of the French king, and as late as 1792, July the fourth was celebrated in the streets with joyous toasts to Louis XVI.[2] On the other hand, by 1792 Philadelphians were deeply committed to supporting the cause of the French revolutionaries. One especially spectacular event was staged on June 11, 1794, when Philadelphia celebrated in honor of the citizens of France. The day began with a ten-gun salute by French and Americans around an obelisk decorated with the insignia of liberty and draped with American and French colors. Young people dressed in white danced around a ribboned pole. The obelisk was paraded around Centre Square to the house of the French minister, at Twelfth and Market streets, by four French and American soldiers in uniform and wearing red liberty caps. The day ended with speeches, dancing, fireworks, singing of the *Marseillaise,* and burning of the British flag on a greensward that had a statue of Liberty at the center.[3]

Many thought that the fate of the aristocrats and monarch in France was cruel and unjust, but the aristocrats in residence in Philadelphia did not flaunt either French style or their political convictions. Philadelphia was accustomed to temporary visitors from all over the world as part of daily life, for the city had been the headquarters of administrations during both war and peace. When Frenchmen such as Moreau de Saint-Méry; Jean Nicolas Demeunier; Charles Maurice de Talleyrand-Perigord; the duc d'Orleans, future king of France; and his brothers the duc de Montpensier and compte de Beaujolais arrived, they were treated with respect. This group never called Philadelphia home; they kept in close touch with events in France and were alert to changes that would allow them to return. Moreau de Saint-Méry described his friendship with Talleyrand in terms that make clear the importance of such connections

Figure 32
Armchair in the Louis XVI style. By Adam Hains (American, Philadelphia, 1768–after 1820), 1792–97. Mahogany, height 34″ (86.4 cm). Museum of Fine Arts, Boston. Otis Norcross Fund, William Francis Warden Fund, and a gift of a friend of the Department of American Decorative Arts and Sculpture.

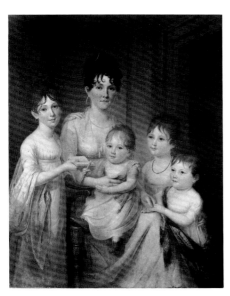

Figure 33
Portrait of Marie Françoise Truchon de Lorriere Dubocq and Her Children, by James Peale (American, 1749–1831), 1807. Oil on canvas, 51 x 41" (129.5 x 104.1 cm). The J. B. Speed Art Museum, Louisville.

to the émigrés: "Every day that [Talleyrand] was in Philadelphia, after we had been reunited, from October, 1795, up to the present time [June 1796], he came to my private office at eight o'clock in the evening. There alone and without interruption . . . we opened our hearts to one another, we poured out our feelings; and each of us knew the others most intimate thoughts."[4] Until March 1796 they had their own small newspaper printed in French by Saint-Méry. They lived here and there, all over the city. The Philadelphia directory for 1798 lists the duc d'Orleans simply as a merchant on Fourth Street; there is nothing conspicuous or distinguished about the entry. Talleyrand lived on South Second Street at the corner of Spruce but ate at Théophile Cazenove's house in Market Street, as did Saint-Méry, the Count de Beaufort, and M. de Liancourt, who was at the time writing his treatise on the prisons of Philadelphia.

The impressions that Philadelphia made on these French observers reveal their curiosity about American democracy. Saint-Méry's view of George Washington shows an awe at the lack of ceremony in American politics: "I went to see Washington open Congress and hear his opening address. How wholly simple and natural it was. This was Washington! This was the gathering of representatives of a nation that has won its liberty! What vast and great ideals in a group so united! How these republican forms appeal to the soul and stir the heart. What a destiny they foretell for this part of the world!"[5]

French ingenuity contributed to culture and comfort throughout the Federal period. Newspaper notices and advertisements were full of new opportunities. Monsieur de Quesnay, "a lively and ingenius Frenchman," introduced performances of illuminations and French dances. There was "Hypolite Philip Hair dresser from Paris," who advertised that "he has just received a most elegant assortment of Wigs, long and crops, Scalps, Frizetts . . . [also] a new invoice of fresh PERFUMERY . . . comprising Vinaigre de Rouge of the finest quality . . . [and for] the many tufts of hair already made for several gentlemen . . . a *pomatum newly invented,* and of which he is the proprietor, will . . . nourish and preserve their natural hair."[6]

Accounts, receipts, and diaries have regular entries describing the pervasive influence of France in Philadelphia. Commerce played its part. John Dubarry's receipts show longstanding accounts with the French firms Lafitte Beauvrie, John W. Foussate, and L. Bonnet, as well as consignments from Lewis Clapier and other French Philadelphians.[7] During the fad for all things French, window glasses were imported by Joseph and John Rozet for everyone from Jefferson to Benjamin Rush, and wallpapers were imported by Anthony Chardon. William Dubocq (or Dubacq, or Dubosq), a citizen naturalized on April 26, 1804, estab-

lished himself as a china merchant in 1805; he and his family lived near Second and Pine streets between 1805 and 1818. Dubocq spent some time on the high seas as supercargo in the import trade. As a merchant he was typical of many of the French arrivals: he presumably continued to use trading connections he had established in France. The large and grand group portrait of his wife, Marie Françoise Trochon de Lorriere Dubocq, and their four children, painted in 1807 (fig. 33), must have been an important and unusual commission for James Peale, who by this time was specializing in miniatures. The Dubocqs are painted with an immediacy and individuality that suggest Peale knew this family well. They are shown in the most fashionable attire of the period, with all but the baby boy wearing jewelry. The figures are set in what appears to be a domestic interior, next to a window or a door with typical Philadelphia woodwork. The Dubocqs had arrived in Philadelphia during the constructive, progressive period before the War of 1812, when Philadelphia shipping was extending into European and some Far Eastern ports. Frenchmen already established in Philadelphia, such as Lewis Clapier, Stephen Girard, Anthony Chardon, Claude Amable Brasier, Simon Chaudron, and Charles-Balthazar-Julien Févret de Saint-Mémin, to name a few, organized a benevolent society that helped some French émigrés to ease transitions. Schools also helped. The widow of a French military engineer, Mme Rivardi, from a noble Viennese family, opened a school on Chestnut Street where young ladies, including Victorine du Pont boarded. She arrived with her parents in 1800 from France,[8] lived in Wilmington, and came to Mme Rivardi's school in Philadelphia in 1805, where she was schooled in English as well as art, needlework, and dancing. In keeping with European custom, she received a gold reward of merit, in 1807 (fig. 34).

Americans who had gone abroad for trade or for government business, such as Robert Morris, his unrelated associate Gouverneur Morris, and Thomas Jefferson, were fluent in French and were among the francophiles in Philadelphia who equipped themselves with things French. All three men imported furnishings for their Philadelphia houses. Jefferson's packing lists reveal that almost his entire Paris household, from curtains to books, was shipped from his *hôtel* in Paris to his rented house on Market Street in Philadelphia. Robert Morris, a broker with a three-year monopoly of the tobacco trade between France and America, imported tapestries, chairs, and so forth, but—what may have been most impressive and enjoyable for Philadelphians—he also secured a series of French cooks.[9] Morris set about building an enormous house on an entire block on Chestnut Street at Ninth and employed Pierre Charles L'Enfant to design it (fig. 35). Although the house was never finished, the exterior,

Figure 34
Award of merit won by Victorine du Pont at Mme Rivardi's Philadelphia boarding school. By Francis Shallus (American, Philadelphia), 1807. Gold, diameter 1³⁄₁₆″ (3 cm). The Henry Francis du Pont Winterthur Museum, Delaware.

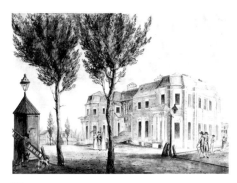

Figure 35
The Unfinished House on Chestnut Street,
Robert Morris's grandiose *hôtel* in Louis
XVI style. Drawn by William Birch
(American, born England, 1755–1834),
c. 1799. Watercolor and ink on paper,
8 x 11" (20.3 x 27.9 cm). The Library
Company of Philadelphia.

so different from the Philadelphia style, was an attempt at a French, urban, *hôtel* style, with a roof reminiscent of seventeenth-century designs by François Mansart. The rest of the composition was a complex alternation of brick façade with marble porches and marble window surrounds probably carved by Peter Stagge, whom Morris paid in 1796.[10] The house was like a Louis XVI *hôtel* on the street in the fashion of Paris in the 1770s, when great pedimented entrances were abandoned for all-around compositions of alternating materials and architectural projections of piers and pilasters. Morris hired John Faipoux for the large ironwork, including the lanterns on the roof, which were French elements also used by Latrobe for the Bank of Pennsylvania and William Waln's house. One of Morris's decorators, Giuseppe Provigny, listed himself in the Philadelphia directory for 1798 as a composition marble worker at 107 North Second Street. Peter de Beauvais was the painter whom Morris hired to ornament the interiors. Deborah Norris Logan wrote to her mother about Morris's plans on March 25, 1793: "Robert Morris is going to build a superb house on the lot he purchased of Cousin Dickinson it is designed to be 140 feet front."[11] Latrobe later described the chaos of the effort: "The windows . . . are cased in white marble with mouldings, entablatures, architraves, and sculpture mixed up in the oddest and most inelegant manner imaginable; all the proportions are bad, all the horizontal and perpendicular lines broken to pieces, the whole mass giving the idea of the reign of Louis XIII in France or James I in England. . . . In the south front are two angle porches. The angle porches are irresistibly laughable things, and violently ugly."[12]

That no one seems to have commented on Morris's snubbing native Philadelphia talent in his preference for French services—J. B. Le Maire as fencing master for his son Charles, Monsieur Sicard as dancing instructor, or F. Poirez as hairdresser—implies that the new French arrivals filled a need in the life of the city, and that many citizens took advantage of the émigrés' specialties and skills. The bills Morris paid for china and millinery from Le Havre suggest that Mrs. Morris's hats—perhaps the extravagant one shown in a portrait of her by Charles Willson Peale—were unsurpassed for the latest style.

During the War of 1812, America again became the subject of curiosity in France. Dr. Antony Plantou, a dentist, and his artist wife came to Philadelphia at this time. She was first listed in the Philadelphia directory in 1819 as a portrait painter at 151 South Third Street. Mrs. Plantou had been a pupil of the French painter Renaud and was familiar with the heroic history painting fashionable in France and England. She painted *The Peace of Ghent and Triumph of America* in 1818 and exhibited a huge version of it (7 by 11 feet) first at her husband's house on Third Street.[13]

The subject was issued as an engraving (fig. 36) celebrating a specific American triumph. It may have been the engraver Chataigner, another Frenchman, or Philip Price, Jr., a clock- and watch-maker at 31 South Fourth Street in 1813 and at 71 High Street in 1819, who first issued the subject as an engraving. Three main groups of figures are spread across this composition and are overlaid with motifs of winged figures, an eagle, the ubiquitous liberty cap, and ancient objects. The architecture sets the stage: the procession has come through the Roman triumphal arch on the right and is headed for the temple of peace, a Greek-style building featuring the ancient Ionic order like Latrobe's Bank of Pennsylvania. In the distance is a large pedimented building, possibly the capitol, an appropriate reference in a print celebrating the victory of the War of 1812.

Simon Chaudron is another French artist who came to Philadelphia about 1790, after a childhood in France, an apprenticeship in Switzerland as a watchmaker, and a stay in the West Indies. He was in Philadelphia by 1798, listed as a watchmaker and jeweller, at 12 South Third Street. In 1800 he added goldsmith to his listing, and in 1813, silversmith. Anthony Rasch, a Bavarian, arrived in Philadelphia in 1804 and is recorded as a partner in Chaudron & Co. in 1809. The pair of silver sauceboats marked Chaudron & Co. are unusually large and very heavy (fig. 37). The snake-modeled handles, textured and twined, are visually arresting because the boats themselves are smooth, with no ornament except the banding at the rims and bases. These sauceboats are an especially handsome and early manifestation of the Greek revival style in Philadelphia and were probably made from a French model or by a craftsman in Chaudron's shop who had just completed a French apprenticeship.

The War of 1812 had stirred national fervor against Great Britain. Napoleon was the "ally" of the United States. The news of Napoleon's defeat at the battle of Waterloo caused great speculation in Philadelphia. On August 21, 1815, Deborah Norris Logan went to the New Jersey seashore, and from a house "with a view of the sea . . . with a good glass however, from the Piazza I saw an English Frigate under full sail passing along. . . . They search, it is here said, every thing that has a Deck for Buonaparte, beleiving that he is endeavouring to come to the U.S. they are furnish'd with a Bust of the ex-emperor with which they compare the Phiz of each individual, amid jokes and laughter. —a French schooner (or schooner from France) was lately overhauled by them, and the very water casks searched for his imperial majesty."[14]

But it was Napoleon's brother Joseph Bonaparte who arrived after Waterloo in 1815, and he was the most prominent Frenchman in Philadelphia since Louis Philippe and Talleyrand. He brought a large retinue

Figure 36
Peace of Ghent 1814 and Triumph of America, after a painting by the wife of French émigré Antony Plantou. Engraved by Chataigner (American, Philadelphia), c. 1818. Etching and engraving on paper, 14 x 16¾" (35.6 x 42.5 cm). The Library Company of Philadelphia.

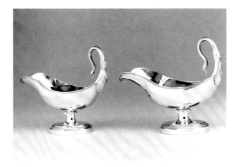

Figure 37
Sauceboats in the French empire, or Greek revival, style. By Simon Chaudron (American, born France, 1758–1846), 1800–1805. Silver, height 8¾" (22.2 cm). Private collection.

and many possessions. His importance was immediately apparent to all the citizenry; the directories used capital letters in his listing. He was also a curiosity, and he brought new focus to things French. Upon arrival he set about finding a place to live. With stewards, secretary, and interpreters, he traveled about, inspecting country properties for his Philadelphia summer residence. Harriet Manigault's description of his visit while on his house hunt suggests that he was not easily satisfied: "In all probability Clifton will soon be disposed of. The *King* of *Spain,* it seems is very desirous of having an establishment near Philadelphia, & as he requires a chateau on a large scale, nothing but that will probably suit him." She goes on to say on April 17, 1816, "Monsieur de Suevilier and his Secretary, Marechal Grouchy, Mr. Parish, & my Uncle Smith went to Clifton on Sunday. . . . He was very much surprised (I mean the King) at finding books in almost every room. . . . He appears much pleased with the house, but not with its *entourage.* This same *Joseph* paid us a visit last night . . . he is short & fat, has a most good-natured countenance, and looks more like a farmer than a *King.* He does not speak a word of English."[15] Bonaparte finally leased Lansdowne, the largest and grandest villa on the west bank of the Schuylkill, which had been built by John Penn and was then owned by William Bingham's estate. He immediately invested in land and in 1817 began to develop an estate at Point Breeze in New Jersey. In town he rented the biggest house available, John Dunlap's, on a city block between Market and Chestnut and Eleventh and Twelfth streets. Then he bought a house at 260 South Ninth Street (corner of Spruce), a room of which was papered with a French series of Cupid and Psyche panels in grisaille. The Bonapartes liked Philadelphia. Both his daughters visited him; Zénaïde came with her husband, Charles Lucien Bonaparte, in 1822 and settled in.

Just before the marriage of their daughter Zénaïde in 1822, Bonaparte's wife, Marie Julie, commissioned Jacques Louis David in Brussels to paint a double portrait (fig. 38) of their daughters Charlotte (left) and Zénaïde, who are shown reading a letter with the heading "Philadelphie," presumably from their father. The painting was sent or carried by Zénaïde to Bonaparte in Philadelphia. Generous with his paintings, he lent the portrait to the Pennsylvania Academy of the Fine Arts for their annual exhibition on May 12, 1823. A reviewer who signed himself LAOCOON included a short notice: "David has his 'Napoleon Crossing the Alps,' and in the Gallery, two portraits (in one picture) of the daughters of the Count de Survilliers [Bonaparte's title]. There are ten well executed pieces by the accomplished Countess Charlotte de Survilliers."[16]

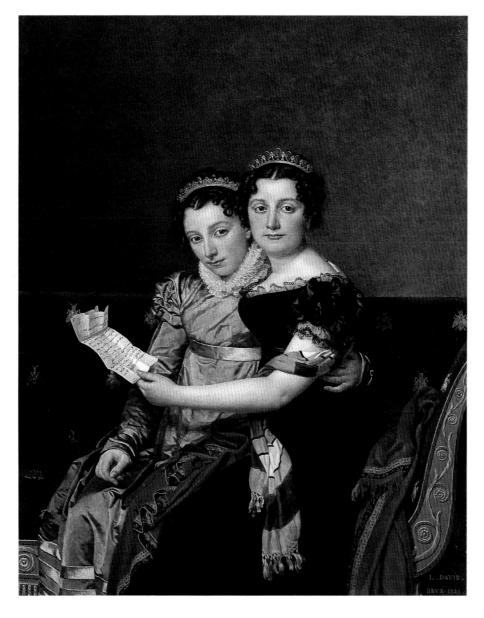

Figure 38
*Portrait of Charlotte and Zénaïde
Bonaparte,* the daughters of Napoleon's
brother Joseph. By Jacques Louis David
(French, 1748–1825), 1821. Oil on
canvas, 51 x 39⅜" (129.5 x 100 cm).
The J. Paul Getty Museum.

French Wallpaper

Plate 14
Wallpaper, "Voyages du Capitaine Cook"
Designed by J.C. Charvet (French)
Printed by Joseph Dufour et Cie.
(French)
1804–6
Block print on paper, each panel 105 x
44⅜" (266.7 x 112.7 cm)
Philadelphia Museum of Art. Gift of Dr.
Anne Mitchell McAllister in memory of
her father, William Young McAllister,
21-43-1a,b

Bills of sale, newspaper advertisements, receipt books, and diary entries record the presence of wallpapers of all descriptions in Philadelphia houses by 1800. Philadelphian Thomas Hurley advertised in the *Pennsylvania Packet* for October 5, 1786, "Paperhangings put on in the neatest manner, by Thomas Hurley, at the usual moderate price of 1 sh 6 per piece on plain walls, or 3 sh for pasting on paper and canvas, which he warrants to execute so as that no damp can long after affect his paper." Wallpapers in French patterns were printed in Philadelphia by Anthony Chardon, who also imported French wallpapers, which were by far the most popular.

Almost every receipt book from 1785 to 1825 records the purchase of and hanging charges for wallpapers, in city houses and those far out in the countryside. Dr. Benjamin Rush papered several rooms; Ann Pemberton specified green borders and festoons; Anthony Morris at the Highlands in Whitemarsh ordered French scenic paper for his hallway. In 1789 the Binghams had arabesque paper by Reveillon in their salons. In 1790 Jefferson received 145 rolls from Arthur and Robert in Paris: a brick pattern for his hallway and a sky blue, pea green, and crimson faux drapery pattern with festoon borders and specially designed corner papers that ornamented the corners of a room like curtains.

Many sets of French scenic papers were imported and installed in Philadelphia houses: Joseph Bonaparte had Cupid and Psyche in 1817, and the colorful Voyages du Capitaine Cook, printed by the French firm of Joseph Dufour et Cie in 1807, was a popular edition. Harriet Manigault described a set in 1815: "We called upon Mrs. Claudius who as usual was all gracious. Her house is most diminutive, & gives one the idea of a cabin of a vessel; it is papered very prettily in large landscapes, & the ceiling which is very low, is done in blue paper to imitate the sky."[17]

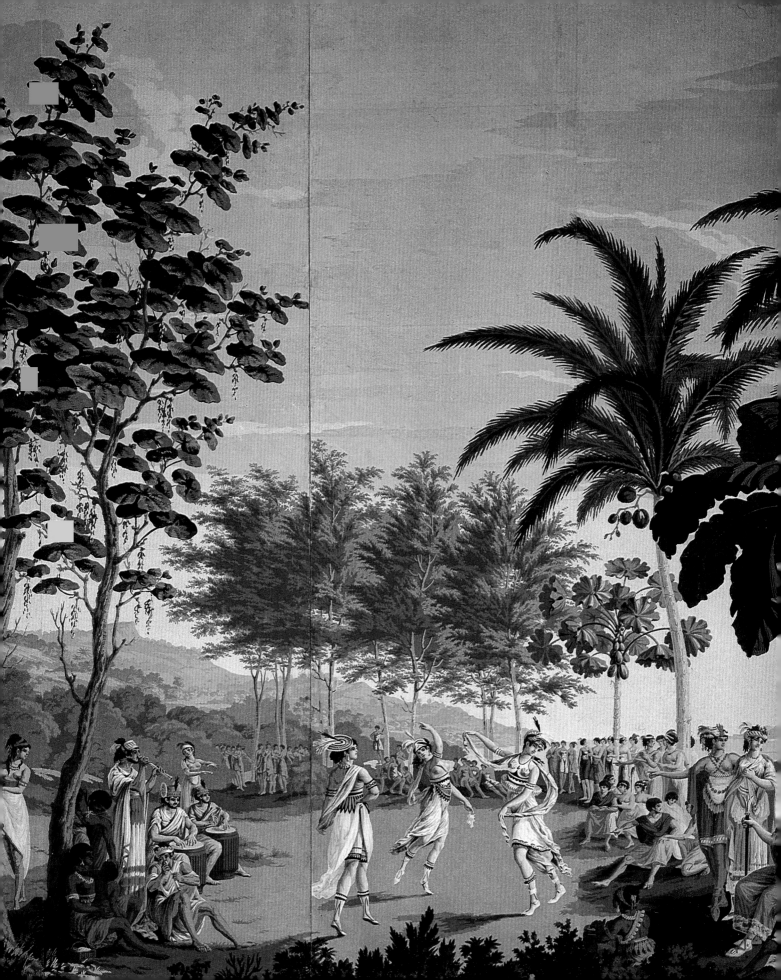

Railings in the French Style

The designs of the railings that sur-mounted the east and west flat-roofed facades of Stephen Girard's countinghouse have a distinctly French character. The flowing cyma shape of the scrolls, which converge to support a central motif—the wheat sheaf and the sailing ship—is almost identical to that of railings found on Paris houses dating from 1728 to 1740. Even the small zig-zag motif at the bottom of the boat is the same as that on a Paris house of about 1740 at 47 rue Saint-Andre-des-Arts. The panels of railing that fit each side of the more elaborate scrolled units are also typical of French design and were used in the same way on Girard's building as on French balconies—to provide visual stability for the rococo designs of the center panels. One of these panels had the date 1796 in ornamental ironwork, centered where the sheaf of wheat appears on this panel.

French ironworker John Faipoux, who worked extensively for Robert Morris until Morris's finan-cial reverses required him to lay off his house-building team, was also employed by Stephen Girard. Faipoux signed four entries in Girard's receipt book in 1796, from June 1 through December 24. There seem to have been problems between patron and craftsman, for Faipoux wrote in June 1797, "After the sacrifices I have made you will kindly permit me to insert in all the newspapers an account of what has happened between us, . . . the facts will show that I have kept a certain verbal agreement and that you were solely guided by interest when you made me certain propositions which are repugnant to a man of honor." Dame Faipoux made a fervent plea for payment: "The trouble I am in at the moment, my husband being ill, forces me to interrupt you perhaps too often. I am not asking you to lend me money; if you will kindly search your memory, you will find that I am not asking you for too much. If you will have the humanity to pay me, you will render me a great service; for I have neither wood nor any money to go to the market with, and four children crying from cold and hunger. . . my husband asks you to pay him his note for forty gourdes. Please do not disregard my letter, for I am waiting near the woods. You will oblige her who has the honor to be, Dame Faipoux."[18] Girard paid ten dollars to Faipoux on September 29, 1798. Faipoux was listed only once, in 1798, in the Philadelphia directory, as a whitesmith on Arch Street between Ninth and Tenth streets. He may have been one of the French workers who was encouraged by Robert Morris or Pierre Charles L'Enfant to work in Philadelphia, and when Morris's affairs unraveled in 1797–98, Faipoux fell upon hard times. Whether he made these Girard railings is not determined, but the maker had either had a strong French apprenticeship or was working from the very specific, if old-fashioned, design book from which the above cited Parisian railings and balconies were derived. Faipoux seems a strong possibility because he made the special ironwork for Morris's French-style house, and because his listing as a whitesmith indicates a specialty in finishing ironwork. One of the railing panels is seen in place in the watercolor, painted about 1831 for Zachariah Poulson, showing Girard's house and countinghouse (fig. 39).

Plate 15
Iron Railing
American, Philadelphia
1796
Wrought and cast iron, copper alloy, and modern gilding, 38½ x 60¹³⁄₁₆" (97.8 x 154.5 cm)
Philadelphia Museum of Art. Purchased: Joseph E. Temple Fund, 21-24-1

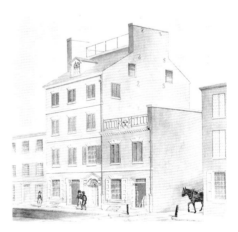

Figure 39
Stephen Girard's House and Counting-house, with the iron railing in place above the second story. c. 1831. Watercolor on paper, 13 x 13" (33 x 33 cm). The Library Company of Philadelphia.

A Sense of Style

Figure 40
Title page of *The London Cabinet Book of Prices*, published in London in 1788 and in Philadelphia in 1794 and 1796 with the costs of numerous design elements. London, 1788. Etching and engraving, 10⅜ x 8⅜" (26.3 x 21.3 cm). Library of the Philadelphia Museum of Art.

Philadelphia style had its own particular flair and personality, easily recognized in its domestic guise. Before the capital moved from New York to Philadelphia in 1790, few in Philadelphia were deliberate in trying to be fashionable and to set style. The William Binghams were one couple who did make Philadelphians aware of style as practiced abroad, particularly in London, but by no means all of their introductions were adopted. John Watson reported that when William Bingham paraded in the hot summer streets accompanied by a mulatto who held an umbrella to shade his head, it was called "a ridiculous effeminacy," and that "his example did not take, and he desisted from its use."[1]

Philadelphia patrons and craftsmen in the early Federal period were working with models and designs from the late phases of Chippendale rococo and from the neoclassical style of Robert Adam. Those styles suited Philadelphia architecture well, not requiring extensive changes in building technology or in coloring. Furniture inlays were both imported and made in Philadelphia shops. Inlays with eagles, shields, and thirteen stars were set into tall clocks, sideboards, card tables, and looking glasses. The iconography appealed to Federal America, and the eagle with a shield continued to be popular until the 1820s, when it was replaced by the gilded imperial eagle of the Greek revival style.

The design books in use in Philadelphia after the war were George Hepplewhite's *Cabinet-Maker and Upholsterer's Guide*, published by his widow in 1788, and Thomas Sheraton's *Cabinet-Maker and Upholsterer's Drawing Book* of 1793 and 1794. New forms, furnishing details, and room arrangements were all illustrated in great detail. Previously, in the books of Thomas Chippendale and Abraham Swan, there were only a few plates showing furnishings and arrangements, but at that time rooms and the arrangements of furniture were as traditional as their style. The book that changed style in Philadelphia was *The Cabinet-Makers London Book of Prices* (see fig. 40), which was issued in Philadelphia in 1794 and 1796. This cabinetmaker's manual describes every facet of all kinds of furniture forms, and the patron selected various elements from it and paid accordingly. Thus design and price were related, and there can be no doubt that this influenced style in Philadelphia. Even Stephen Girard, who commissioned Ephraim Haines to make his famous parlor furniture in ebony, followed this manual and stayed within the categories of shapes and details as outlined in the small, unillustrated book. Girard, a worldly Frenchman of means, could have ordered any exotic design but preferred the local style.

In 1798, when Benjamin Henry Latrobe came to town, he introduced another vocabulary of style into Philadelphia life—first in his public architecture, and then in his commissions for private houses. Latrobe's

letters to his young Philadelphia clients show clearly that he knew all about style. He argued his points and in at least two important commissions—those of William Waln and John Markoe—won his case. His style was antithetical to that of Robert Adam. He wrote to John Wickham in Richmond on April 26, 1811, "In the decoration of rooms, there should be a regular gradation from the plain Hall to the ornamented drawing room, and the Lady's boudoir. But a Hall surrounded with wooden columns empty niches and all of the wood cracked, faded, or smoked, a whitewashed or papered plain walls in the principal apartments inverts all my ideas of good taste."[2] Latrobe's style had come from his architectural connections made in London while in the office of Samuel Pepys Cockerell. He knew Sir John Soane and the spectacular remodeling at Carlton House by Henry Holland. Latrobe's house façades, floor plans, and furniture designs are suave renditions of the earliest manifestations of historical classicism, which was just blossoming in London when he departed in November 1795. Classical antiquities, ruins, vases, sculptures, and paintings were collected and illustrated in books such as those of Charles H. Tatham. The fine lines of Greek vase painting were adapted to book illustration by John Flaxman. Latrobe referred to Flaxman's illustrations for the *Iliad* often, and his decorator George Bridport painted versions of Flaxman's illustrations as a frieze in Waln's drawing room. Folio volumes of Sir William Hamilton's antique vases, Soane's folio of Pergolesi's designs, and a folio of architecture, sculpture, and painting in the antique style by F.A. David were in Bridport's library in Philadelphia. Charles Percier and P.F.L. Fontaine's *Recueil des décorations intérieures*, issued first in sheets and then bound, illustrates the ideas of French classicism with which Latrobe was familiar (fig. 41). Latrobe practiced what Percier and Fontaine recommended: furniture is so closely allied to interior decoration that the architect has to be concerned with it. Latrobe designed a suite for the Bank of Philadelphia, chairs for Joshua Gilpin, furniture for Waln's dining room and a painted suite for his drawing room (pl. 24), as well as all the furniture for Markoe's house. Later architects such as William Strickland, Robert Mills, and John Haviland lacked Latrobe's experience in London, and they did not continue his practice of designing furniture for interiors; choices of furnishings returned to the domain of craftsmen and householders.

Philadelphians had long had access through lending libraries to newspapers and books, which they read and discussed. Popular publications like Rudolph Ackermann's *Repository of Arts*, which included colorful illustrations, often had swatches of textiles for furniture and dress to encourage thinking about style or adopting new ones. A typical enticement appeared in the *Repository* in 1809:

Figure 41
Plate from *Recueil des décorations intérieures,* published in Paris by Charles Percier and P.F.L. Fontaine, showing a bedroom decorated in the later French neoclassical style. 1812. Etching and engraving, 11¼ x 17½" (28.6 x 44.4 cm). Library of the Philadelphia Museum of Art. Gift of Henry P. McIlhenny.

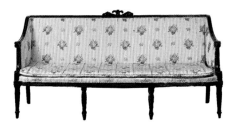

Figure 42
Sofa designed with elements from George Smith's *Collection of Designs for Household Furniture and Interior Decoration* (1808). Attributed to Joseph B. Barry (American, born Ireland, 1757?–1839), 1805–10. Mahogany, 36 x 75" (91.4 x 190.5 cm). Private collection.

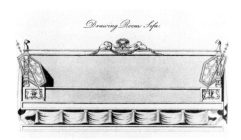

Figure 43
Plate from George Smith's *Collection of Designs for Household Furniture and Interior Decoration,* showing a sofa with a central embellishment of ram's heads similar to that used on the sofa attributed to Barry. London, 1808. Etching and engraving on paper, 8½ x 11½" (21.6 x 29.2 cm). Private collection.

A considerable alteration has taken place in the style of fitting up apartments within these few months. Instead of a gaudy display in colouring, a more pleasing and chaste effect is produced in the union of two tints. . . . We have witnessed this effect in a full crimson damask pattern, lined with a blue embossed calico. . . . A similar taste has been followed with some success in a paper-hanging, exhibiting a rich appearance, when finished with gold, or black and gold mouldings.[3]

Most of the pieces illustrated by such publications had to be purchased in London. Finding on the docks in Philadelphia, or in any other American city, precisely the goods to create these effects would have been serendipitous. When Latrobe was decorating the great drawing room in the White House for Dolley Madison, he searched the eastern seaboard for red damask and finally settled for red velvet, which he found in the upholstery shop of John Rea in Philadelphia. Latrobe knew the sources of the newest styles, and he understood how to achieve their effects with what was available.

Latrobe had introduced the Greek revival style in its early, purest form directly, before the English designers Thomas Hope and George Smith published their books in 1807 and 1808. Through such books a myriad of forms from classical antiquity entered the public domain, and they became another source for the Greek revival style with a French twist, as practiced in Philadelphia. George Smith's *Collection of Designs for Household Furniture and Interior Decoration* (1808) illustrates designs adapted and simplified from Grecian, Etruscan, Roman, and Egyptian styles. Details from various plates in Smith's design book would be used to make one eclectic composition (see figs. 42 and 43).

Philadelphia silversmiths were especially adept at shaping new forms without being well educated about a new style. The great silver tea urn made by Richard Humphreys for Charles Thomson (frontispiece) is the most spectacular example of how fast a style could be adopted and how versatile Philadelphia craftsmen were when commissioned to work in a new vocabulary. Because it was considered currency with assayable value, silver traveled quickly. And imports, especially "smalls" (buckles, cuff links, snuffboxes, caddy spoons), were models for new techniques of decoration, from bright cutting to casting. Foreign styles were only as far ahead of Philadelphia craftsmen as the time it took to sail across an ocean. Philadelphia style included as many variations as the world of trade offered.

New Styles

According to *The Cabinet-Makers' Philadelphia and London Book of Prices*, published in Philadelphia in 1796, shield-shaped chair backs with rounded bottoms as seen on the following page were called urn backs. Urn-backed chairs were the most popular seating form made in Philadelphia between 1785 and 1800, as opposed to the pointed-bottom shield shape, called a vase, used most often for chair backs in New York and New England.

The urn and vase designs were daringly different from both the rectilinear and the flamboyantly curving shapes used in earlier periods and allowed a myriad of fanciful splat motifs. These three patterns of urn backs (pl. 16) are typical of Philadelphia's interpretation of George Hepplewhite's designs in *The Cabinet-Maker and Upholsterer's Guide*, which was published in England in 1788 (see fig. 44). The center urn back was inspired by Hepplewhite's plate 7, although the tulip shape at the center of this back looks like a Pennsylvania German rendition of a bellflower. There were almost as many options, and prices, for seat and leg designs as for splats. Every type was available in Philadelphia: the slip seat and the seat upholstered over the rails; the straight and the serpentine front rail; and carved, inlaid, molded, and fluted legs with and without stretchers.

Chairs in this style, especially those upholstered over the seat rails and ornamented with brass-headed tacks, were generally done in black haircloth. It was sturdy, and its color was fashionable and serviceable for dining room use. Nearly all upholstered furniture was also slipcovered, in printed linens, calicoes, checks, and plain muslin. Surviving slipcovers are loose fitting, with both ruffled and tailored skirts, cording, decorative tapes, and fringes that hang over the rails. They would be secured at the back with strings made from the fabric or with woven tape.

After 1800 taste in chairs returned to rectilinear designs. Represented here by three examples in mahogany and maple, the new designs were conservative renditions of English and French classical styles and were developed from publications such as Rudolph Ackermann's *Repository of Arts*, Thomas Hope's *Household Furniture and Interior Decoration* (1807), and George Smith's *Collection of Designs for Household Furniture and Interior Decoration* (1808), which were all in use in Philadelphia. These examples also represent the changed organization of the large Philadelphia furniture shops, where specialists made separate parts and a finisher joined or glued the parts into a whole. The

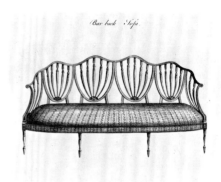

Figure 44
Plate from George Hepplewhite's *Cabinet-Maker and Upholsterer's Guide*, showing a "bar back sofa" with one of the urn-back designs typical of Philadelphia Federal chairs prior to about 1800. London, 1788. Etching and engraving, 8¾ x 14¼" (22.2 x 36.2 cm). Library of the Philadelphia Museum of Art.

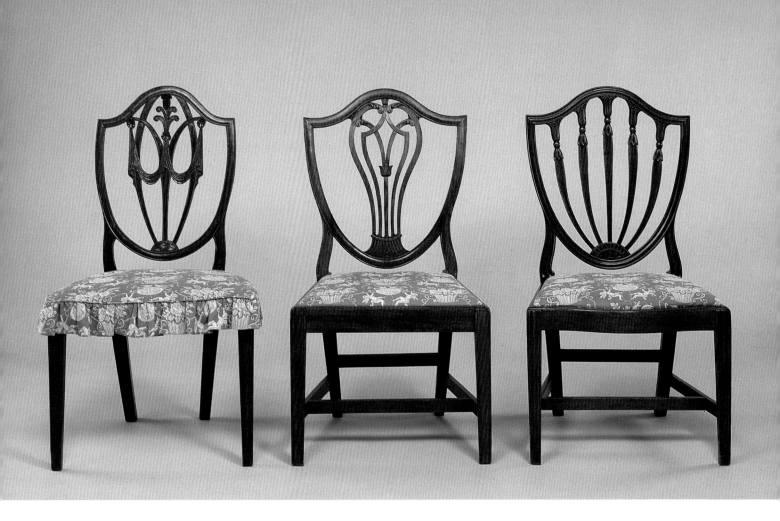

Plate 16
Left to right
Side Chair
American, Philadelphia
1785–1800
Mahogany and chestnut, height 35⅜"
(89.8 cm)
Philadelphia Museum of Art. Gift of
Mrs. Charles Wolcott Henry, 27-10-2

Side Chair
American, Philadelphia
1785–1800
Mahogany and white pine, height 38¾"
(98 cm)
Philadelphia Museum of Art. Gift of
Miss Eliza Royal Finckel, 56-66-1

Side Chair
American, Philadelphia
1785–1801
Mahogany, tulipwood, and pine; height
33⅞" (86 cm)
Philadelphia Museum of Art. Bequest of
Elizabeth Gilkison Purves in memory of
G. Colesberry Purves, 31-34-6a

left-hand rectilinear example, attributed to Thomas Whitecar, illustrates the design problems that this organization presented: the transitions between the parts are abrupt, with the smooth, shaped slats fitted directly against the reeded stiles. Whitecar apparently made this type of chair for the coastal trade, for there are several at Kenmore in Virginia and were several in the Mount of James DeWolf in Rhode Island. Whitecar made eight of these in 1809 for Lydia Poultney, as part of a suite for her dining room at the time of her marriage to James B. Thompson at Philadelphia Friends' meeting. The matching sideboard, breakfast table, and dining table are installed at Cedar Grove, the Morris home in West Fairmount Park.

The central and right-hand rectilinear chairs are closer approximations to classical design. Their flat-sided saber legs sweep into curved stiles, imitating the Greek klismos chair depicted on ancient pottery. The vertical members of the center mahogany example are held together visually by the pierced and carved lower slat and the shaped crest rail, which is ornamented with carved abstract leaves. The removable seat follows the sweeping lines of the rails. The maple, caned chair on the right is part of a suite that includes a small, elegant chaise longue. The immediate prototype for this side chair was an English model called the Trafalgar chair, which was

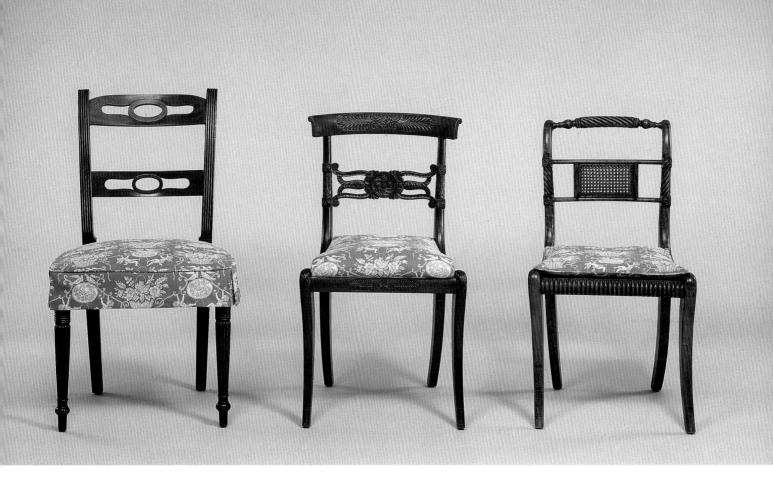

named for the Trafalgar workshops of the London firm of Morgan and Saunders. A popular style by 1805, it continued in use in Philadelphia until after 1825. Since commerce between Philadelphia and London was thriving before the War of 1812, it seems reasonable that examples of these chairs, made in England of beech, arrived in Philadelphia, where they were used as models for chairmakers. The turned molding set into the front rail of this chair was a fashionable extra and was much more comfortable than the complicated twist design on the stiles and crest rail. Maple was always a popular wood in Philadelphia; although not easy to work, it is strong and colorful and retains a crisp line in carved detail.

Caning had a history of being used on only the most fashionable furniture. Replaced by upholstery in the late seventeenth century, it reemerged in late eighteenth-century seating furniture. It was purchased in woven sheets in different patterns. The chairmaker had only to cut a shape and unravel enough strands to tie the piece into the seat frame. Caned seats have a springy, light quality; they are cool in the summer and were made comfortable with a cushion in the winter. They were also economical, as caning was easier to match than upholstery when making repairs to one seat.

Left to right
Side Chair
Attributed to Thomas Whitecar (American, Philadelphia, died 1824)
1809
Mahogany, chestnut, and tulipwood; height 35″ (88.9 cm)
Philadelphia Museum of Art. Gift of Lydia T. Morris, 32-45-100

Side Chair
American, Philadelphia
1815–25
Mahogany, oak, and white pine; height 33″ (83.8 cm)
Philadelphia Museum of Art. The Mary Wilcocks Campbell Memorial Gift. Bequest of Betty Campbell Madeira, 31-42-4

Side Chair
American, Philadelphia
1810–20
Maple and cane, height 32½″ (82.5 cm)
Philadelphia Museum of Art. Gift of Miss Mary Warner Johnson, 28-6-8

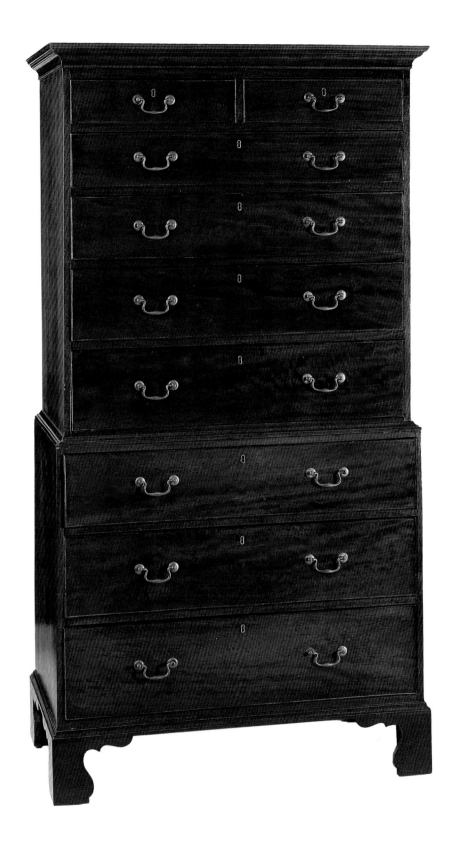

Enduring Philadelphia Forms

The chest on chest had been a popular domestic furnishing in Philadelphia for almost a hundred years by the time Thomas Gross made this handsome example. Although it has no carving or inlaid decoration and makes little reference to period or style, it has the proportion and scale that identify it with the finest Philadelphia work.

Thomas Gross was listed as a "person of colour" in the Philadelphia directories. He probably learned his trade from his father, also named Thomas, who was a carpenter working at 193 South Sixth Street in 1804. By 1807 Thomas, Jr., listed himself as a cabinetmaker with a shop on Mary Street. He went into partnership with Michael Baker, and their listing in the Philadelphia directory was for a cabinet and coffin-making shop in Locust Ward. Until 1809 they worked together as cabinetmaker and undertaker. Gross died about 1839, his widow, Hannah,

and his brothers George, a shoe-maker, and Michael, a carpenter, surviving him. Thomas Gross's house was in Cedar Ward, Philadelphia, which in the United States census of 1820 is described as being racially mixed, with "1047 white families" and "612 coloured families."

Like many Philadelphia cabinet-makers, Thomas Gross spent much of his time making such routine items as benches, doors, window frames, and coffins. For this chest on chest he selected colorfully grained mahogany planks, to which he applied his own skillfully worked techniques. The drawer edges have a fine bead molding. The crisp cornice moldings and the shaped bracket feet are typically eighteenth-century details. The mid-band molding is fastened to the upper section instead of to the base unit, which was the usual practice. The simplicity of the surfaces, without carving, fretwork, or applied moldings, may have been the result of one side of Gross's trade, coffin making. But the elegance of the wood selected and the tight joinery suggest that Gross was well trained in cabinetry. He had a sharp eye for correct proportion and form. That he may also have been pleased with his result is suggested by the form of his signature, written with a great flourish on the bottom of the lowest drawer.

Plate 17
Chest on Chest
Thomas Gross (American, Philadelphia, died 1839)
1805–10
Mahogany, pine, and poplar; height 82″ (208.3 cm)
Philadelphia Museum of Art. Gift of Mrs. Leslie Legum, 1983-167-1a,b

Decorative Style

Plate 18
Tea and Coffee Service
James Howell (American, Philadelphia,
c. 1781–1855)
1811
Silver, height of coffeepot 10¼″ (26 cm)
Inscribed: IAP (James and Anna Pratt)
Philadelphia Museum of Art. Gift of
Mr. and Mrs. Bertram D. Coleman,
1976-40-1–6

This silver tea and coffee service celebrates both style and craftsmanship in Philadelphia. Henry Pratt, a fabulously successful merchant of the postwar generation and the builder of Lemon Hill, commissioned this service in 1811 from James Howell, silversmith, whose shop was at 50 South Front Street. A large set for the period, it would have been displayed on a dining room sideboard when not in use. The pair of smaller pots were for tea and hot water, and the largest held coffee or chocolate.

This set exploits full, rounded forms and the decorative device of bulging flutes. In England and less frequently in Philadelphia, this round design was used as an alternative to neoclassical vase-like forms poised on flat plinths with ball feet. Handsome and superbly crafted as this set is, Howell's apprenticeship in Joseph Richardson's shop may not have given him a complete understanding of the new style. The gadroon banding on the rim of the bases was old-fashioned by 1800; although contemporary in style, the spouts belong with squarer forms; the handles are thin and linear, too delicate for the design of the bodies. Likewise, though most shops by 1800 had adopted the use of sheet silver, the Richardson shop continued the older method of raising hollow forms by hammering silver ingots, a laborious technique that Howell used here in a style more suited to the new, faster method.

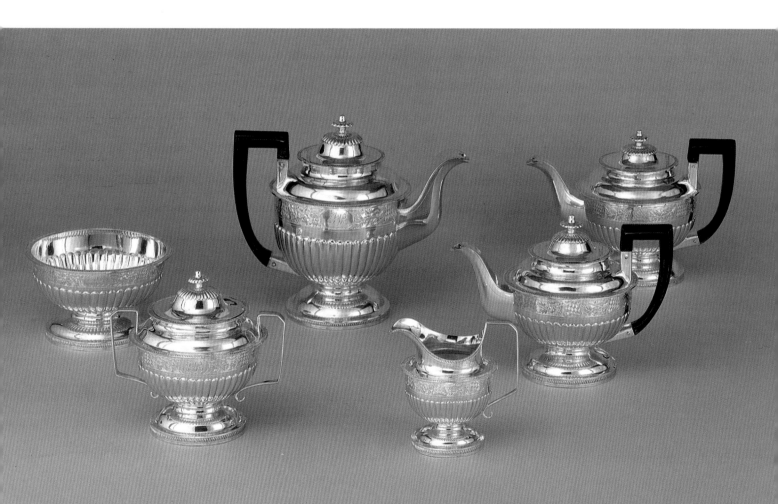

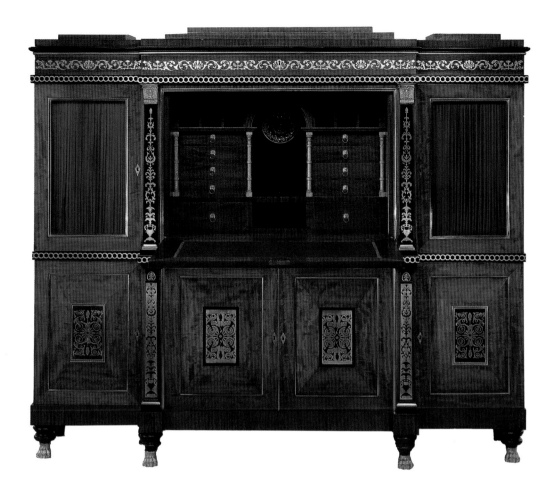

In the French Style

This broad, three-part secretary desk was part of an ensemble of furniture made for the Gratz family of Philadelphia about 1820. It is distinguished by the lavish use of brass and ebony marquetry panels, known as buhlwork, in both positive (*premier partie*) and negative (*contre partie*) designs. Joseph B. Barry, to whom this grand desk has been attributed, was a cabinetmaker who emigrated from London and organized a large shop in Philadelphia. He and his son, who eventually took over the shop, employed European journeymen and advertised furniture embellished with brass work. Barry traveled abroad at least once in 1819

and may have purchased the ornamental panels at that time. Not similar to identified English work by George Bullock or Thomas Parker, they may have been made by Louis LeGaigneur, a Frenchman who operated a buhlwork factory at 19 Queen Street in London in 1815. Barry was not an original designer but an entrepreneur who made furniture in quantity to be shipped in the coastal trade.

Plate 19
Secretary Desk
Attributed to Joseph B. Barry (American, born Ireland, 1757?–1839)
1810–20
Mahogany, white pine, tulipwood, ebony, and brass; 65³⁄₄ x 76³⁄₄″
(167 x 194.9 cm)
Philadelphia Museum of Art. Gift of Simon Gratz in memory of Caroline S. Gratz, 25-76-1

A Moment in the Arts

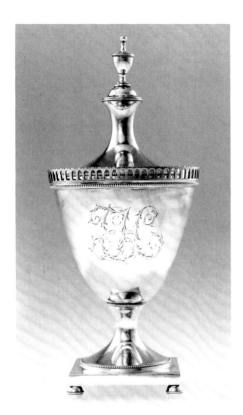

Figure 45
Sugar box in the urn form popular during the early Federal period. By Daniel Dupuy (American, Philadelphia, 1719–1807), 1790–1800. Silver, height 6⅞" (17.5 cm). Inscribed: EH. Philadelphia Museum of Art. Gift of Elsie DuPuy Graham Hirst in memory of her son Thomas Graham Hirst, 60-107-1a,b.

Art was studied, analyzed, and collected, as well as practiced in the Federal period in Philadelphia. It pervaded the cityscape, the elegant interior, conversation at the salons, and even became a subject for tavern talk as art crossed over into the fields of commerce and trade. Practical, sentimental, educational, and intellectual, art contributed to the iconography of nationalism, which included myriad interpretations of classical ideals overlaid with noble sentiments. Artists continued to illustrate political themes, but Philadelphia attempted, in what turned out to be an important moment, to reach beyond the practical and ornamental uses of art and enter the realm of ideas and aesthetic theory.

By the Federal period, the city took for granted the presence of architects, artists, cabinetmakers, silversmiths (see fig. 45), and the mechanical trades. Art and commerce were bound together in patterns of thought and practice. The painters Charles Willson Peale, Gilbert Stuart, and Thomas Sully were busy with commissions. Less well-known artists sought to enter the mainstream by specializing, for example, Robert Street who "Informs the public that he has relinquished Storekeeping, purposing in future to pursue his profession at No. 132 north Second-street, (above Race) where his friends are particularly invited to call and see specimens of his production in PORTRAIT PAINTING."[1]

Commercialism continued to be important; artists had to be salesmen. Newspaper advertisements with a see-it-now-or-never tone attracted an audience, such as this one in *Poulson's American Daily Advertiser* in 1820: "Passage of the Delaware in 1776. Will be exhibited, for a few weeks only, at Earle and Sully's Gallery, No. 169 Chestnut street, an Historical Painting . . . in which is introduced A FULL LENGTH LIKENESS of General WASHINGTON by Mr. Sully."[2] In 1820 a positive critical review of this painting appeared in *Poulson's American Daily Advertiser* noting that "painting seems to be the kindred pursuit of this country, and Philadelphia has been emphatically called the 'Athens of America,' for the decided steps taken in its advancement."[3] The Washington Museum and Gallery of Paintings on Market Street below Second Street advertised: "300 wax statues, 200 paintings, 300 engravings, and very valuable natural curiousities . . . also, 8 large Paintings, Wertmuller's Venus, Bathing Figure, Woodfawn, Danae, the great Aniconda seventy feet in length, destroying a horse and rider, statues, engravings, many valuable miniature paintings, etc. etc., This apartment is 25 cents extra."[4] Interest in the arts continued to be mingled with popular fascination with natural curiosities.

Until the Federal period, transactions involving the purchase or commission of works of art, especially paintings and sculpture, had been handled directly between artist and patron. As the pursuit of art devel-

oped and as artists broadened their subjects to incorporate intellectual issues and not just record a person, place, or thing, the exhibition gallery became prominent in Philadelphia. This may have been the reason why the visual arts thrived in spite of the fortunes or misfortunes of Philadelphia patrons. The dealer provided momentum and stock, in the same way that furniture craftsmen built up inventory for trade and did not depend entirely upon special commissions. The appreciation of art and the zest for commerce ran together. Wills and inventories often list prints, pictures, and paintings; Jacob Rozet's will specified that his son Jacob was to have any two of his paintings or engravings with the frames that he chose.[5] What subjects or artists were represented is unknown but there can be no doubt that art was firmly in the public consciousness and was considered an important addition to the domestic setting. The fresh infusion of artistic talents from abroad, such as Mme Plantou, William Birch, John James Audubon, Charlotte Bonaparte, and John Lewis Krimmel, helped to make art available in the form of colorful prints of popular subjects. The arts might have continued in this satisfactory, pragmatic fashion, mutually satisfying makers and markets except that a few worldly Philadelphians were looking beyond the status quo. They had greater aspirations for art, believing it to be one of man's noble attainments, and they began the pursuit of art for art's sake in Philadelphia. This aspiration affected art education as much as art collecting. The ladies' academies continued, and art schools began at this time. Thomas Birch, an aspiring artist who came to Philadelphia in 1794 with his father William Birch, worked for schoolteacher Talbot Hamilton, who set up an art school about 1803. From 1803 to 1809, Hamilton bought some twenty-two paintings at public auctions, and Birch repaired the canvases and gilded the frames.[6] If Hamilton's purchases included works by marine artists such as Vernet, they may have been the inspiration for Thomas Birch's interest in sea paintings, which began about 1806. *The "United States" and the "Macedonian"* (fig. 46) is typical of Birch's conception of the turbulent sea battles of the War of 1812. In this Federal period, landscapes and seascapes became important subjects to be exhibited and collected.

There are three patrons who stand out as innovators in the field of the arts in Federal Philadelphia. They included the experience of art in their daily lives, read and wrote about it, and seem to have taken for granted that everyone around them was equally interested. Never condescending toward those less sophisticated, Thomas Jefferson, Joshua Gilpin, and Joseph Bonaparte each contributed in idea and fact to the artistic life of the city, in a different way.

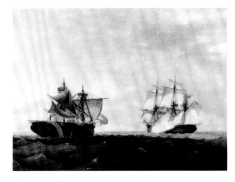

Figure 46
The "United States" and the "Macedonian," typical of the dramatic paintings of sea battles that interested Philadelphians after the War of 1812. By Thomas Birch (American, born England, 1779–1851), 1813–15. Oil on canvas, 24 x 31½″ (61 x 80 cm). Collection of J. Welles Henderson.

Figure 47
Bust of Thomas Jefferson, by Jean Antoine
Houdon (French, 1741–1828), 1789.
Seravezza marble, height 27⅝" (70.2 cm).
Museum of Fine Arts, Boston.

Jefferson never considered himself more than a temporary resident in Philadelphia, as did many others who removed there in 1790 when the seat of government left New York. But Jefferson brought his world with him. He brought 86 packing crates, barrels and trunks full of books, French furniture with ormolu mounts and tapestry covers, 145 rolls of wallpaper, and silk damask window curtains made in two colors in the French fashion, red and blue, which he installed in his Philadelphia house and later at Monticello. In her "Biographical Sketches of the Life and Character of Dr. George Logan" Deborah Norris Logan noted that Jefferson "had resided at the Court of France, and at first appeared in somewhat of its costume and wore an elegant Topaz Ring," but he soon adopted a more republican garb, and was reproached with going to the other extreme as a bait for popularity.[7] Jefferson was a true Francophile. He had traveled around Europe, visited important architectural sites, and knew who the best artists were. In 1785 he and Franklin enticed the great French sculptor Jean Antoine Houdon from Paris to model a portrait bust of George Washington from life, and he came to Philadelphia to see Franklin and to purchase tools on his way to Mount Vernon. In 1789, just before Jefferson left his post in Paris for a short vacation, he posed for Houdon, who sculpted his portrait, first in clay and then in Seravezza marble (fig. 47). The exciting and elegant composition of this bust portraying Jefferson as a lively intellectual reflects the respect artist and patron had for one another.

While Jefferson interpreted and transcribed the Maison Carrée at Nîmes as his design proposal for the capitol at Richmond, Virginia, he also commissioned a mahogany model of a bronze Roman askos, or jug, which had been found on the Maison Carrée site, as a present for the French architect Clérisseau, who had helped with his design project. The first model made in 1787 was lost, and the second arrived after Jefferson had already presented the architect with a coffee urn also modeled from a Roman prototype.[8] Jefferson brought the mahogany model to Philadelphia with him and commissioned Philadelphia silversmiths Anthony Simmons and Samuel Alexander to fashion the askos in silver (fig. 48). Their creation varies somewhat from the model; they added a lid and their handle had a smooth upper surface instead of one ornamented with a stylized leaf decoration. But this unique object reveals clearly Jefferson's individualism, his relentless search for the classical ideals of order and harmony, and his idiosyncratic combinations of the latter with inventive pragmatism. Jefferson was unwaveringly dedicated to promoting the classical ideals of form and style in the United States.

Joshua Gilpin was the merchant prince captured by art, a pragmatist rather than an idealist like Jefferson. A man of action, he differed from

others such as Robert Morris and Stephen Girard who could also claim the title of merchant prince, because his interests took a different direction from merely furnishing a house with fine objects. He smoothed the road toward public acceptance of art and he promoted improvement in all aspects of Philadelphia life. An indefatigable civic worker, he had agents world wide who shipped everything from sculpture from Leghorn, Italy, to carpets from London. He served as an agent in Philadelphia for any number of important matters related to art. Benjamin West wrote to him in minute detail about the room that was to be especially built at the Pennsylvania Hospital to exhibit West's gift to the hospital of the huge painting *Christ Healing the Sick in the Temple.*[9] West also relied upon Gilpin to carry out the details of his wife's gift to the Library Company of West's *Portrait of the Reverend Samuel Preston.* In a letter to Gilpin, West expressed his hopes for the arts in Philadelphia: "As the fine arts are about to take root in New York, I flatter myself that my countrymen in Philadelphia will not be inactive in promoting their growing with them, and that the time will come when your city will have its gallery of the fine arts—and that from the pencils and chisels of their own artists, as well as from those of past ages;—the library now deposited with you will defuse a relish for those eligencies which have ever marked the ultimatum of civilized man."[10] Gilpin got things done and his assiduous attention to public art made a difference. Everyone flocked to see West's painting at the Pennsylvania Hospital. Contributions toward the exhibition room had been collected from a long list of patrons from Stephen Girard and Lewis Clapier to William Thackara and Josiah Lownes, a Philadelphia silversmith.[11]

By 1815, when Joseph Bonaparte arrived from France and Spain, the capital of the United States had moved to Washington, D.C., and the capital of Pennsylvania to Harrisburg. The intense social schedule that had absorbed the energies of the Federal city had abated and Philadelphia refocused on institutions, both old and new, which flourished with new patronage, wider contacts, and city-wide participation. The organization of art began in earnest. Charles Willson Peale's Columbianum in 1794 had been the first association of artists, even if short-lived. The Pennsylvania Academy of the Fine Arts was organized in 1805, not by artists but by a civic group of patrons made up of merchants, lawyers, and bankers. It was this group that Bonaparte joined. Joseph Hopkinson, Bonaparte's neighbor in Philadelphia, was also one of the key organizers of the Pennsylvania Academy and it was through him that Bonaparte lent many of his European paintings. Personally acquainted with important French artists, Bonaparte took for granted the presence of great painting, sculpture, and architecture. In 1822 he wrote to Hopkinson: "All you tell me

Figure 48
Askos, or jug shaped as a wineskin, commissioned by Thomas Jefferson. By Anthony Simmons (American, Philadelphia, died 1808) and Samuel Alexander (American, Philadelphia, died 1847), 1801. Silver, height 8″ (20.3 cm). Inscribed: Copied from a model taken in 1787 by Th. Jefferson from a Roman Ewer in The Cabinet of Antiquities at Nismes. The Thomas Jefferson Memorial Foundation, Inc., Charlottesville.

concerning the painting [*Napoleon Crossing the Alps*] by David now on exhibition in your Academy, will be transmitted to him together with your letter. The praise of cultivated men is the sweetest reward of great artists."[12] Bonaparte's activities connected with his collection, conducted from his houses in Philadelphia and from his New Jersey estate Point Breeze reveal that he dealt with art easily and unselfconsciously. Later, in a letter to Hopkinson, he suggested bargaining with John Hare Powel for his grand country house Powelton on the west banks of the Schuylkill and he proposed to pay Powel in paintings by Titian, Rubens, and Van Dyck because he did not have access to cash or commercial credit.

Bonaparte was an active member of the Pennsylvania Academy and he lent and gave generously for their exhibitions. In 1819 he wrote to Hopkinson, "I have accepted with gratitude the gift made me of the portrait of the Emperor, my Brother. I remember the wish that you expressed to see a portrait of my brother at the Society of which you are the President and I am member. I beg of you Sir, to have the Academy of Fine Arts of Philadelphia accept its respectful donation; it will be at your disposal at Mr. Sully's, to whom I am entrusting the restoration. . . ."[13] Bonaparte moved often and the academy seems to have accommodated him with storage loans. In 1822 he directed that the academy pack up one of his several historical paintings, *Charity* or *The Visitation* or *The Flagellation,* to be sent on loan to the Academy of Fine Arts in Charleston, South Carolina. Bonaparte lent works by Vernet and *The Chase of Diana* by Rubens to the Pennsylvania Academy. The double portrait of his daughters (see fig. 38) was listed as a loan only once in 1823, and must thereafter have hung in his house on Ninth Street in Philadelphia and then at Point Breeze, where it remained until 1836. Thomas Sully visited Bonaparte at Point Breeze and commented on Titian's *Lucretia,* Velázquez's *Deer Chase,* and paintings by Guido Reni and Rubens.[14] Both of his daughters Charlotte and Zénaïde were in Philadelphia at various times with their father, and Charlotte, who had studied with David in Paris, was considered an artist in her own right. She exhibited at the Pennsylvania Academy in 1822, 1823, and 1824, and completed some illustrations that were published in 1824.

How or when Bonaparte sold some of his pictures is not known, but a front-page advertisement in the February 25, 1819, edition of *Poulson's American Daily Advertiser* may describe one such sale: "The Pennsylvania Academy of Fine Arts have just received for Exhibition, and *Sale,* three Pictures, by Titian, Georgione, and Lucas of Leyden . . . A Certificate from the Secretary of the Academy of Arts in Paris, given by order of the Board of Directors, including their Valuation, can be produced to satisfy all doubts of their originality."[15] Bonaparte may have played a role in

Figure 49
Danae and the Shower of Gold, the first image of a nude to be exhibited in Philadelphia. By Adolph-Ulric Wertmüller (Swedish, died America, 1751–1811), 1787. Oil on canvas, 59^{1}⁄₁₆ x 74^{13}⁄₁₆″ (150 x 190 cm). Nationalmuseum, Stockholm.

securing a version, if not the original, of David's enormous (30 by 27 feet) rendering of *The Coronation of Napoleon* for exhibition at Washington Hall in August 1826. An advertisement noted that it had all the participants "in their appropriate attitudes" and that the "picture has cost the present owners 75,000 francs."[16] Admission was twenty-five cents to view the painting. An Italian copy of Joseph Bonaparte's will, which arrived in Philadelphia in August 1844, listed several bequests to Philadelphia friends, and to his nephew François Clary, who was bequeathed two large paintings by Frans Snyder, *The Boar's Hunt* and *The Creation*; the former is now in the Philadelphia Museum of Art.[17]

Adolph-Ulric Wertmüller arrived in Philadelphia in 1795 with several paintings and was helped through customs by Charles Willson Peale and Rembrandt Peale. Wertmüller's large painting *Danae and the Shower of Gold* (fig. 49) became a *cause célèbre*. The *Danae* was the first image of a nude to be exhibited in Philadelphia. Wertmüller knew little about Philadelphia conservatism, and both he and his *Danae* retired almost immediately to the country. As Philadelphia became more aware about art, curiosity about the notorious *Danae* encouraged Wertmüller to bring the painting to the city. Wertmüller had rented a room in a small house on Cherry Street, which had no facilities for advantageous presentation of his painting. He had perched it on two carpenter's sawhorses and held it

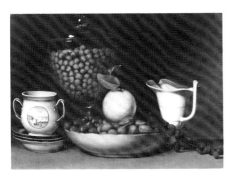

Figure 50
Still Life with Strawberries, representing one of the many kinds of painting that members of the Peale family mastered. By Raphaelle Peale (American, 1774–1825), 1822. Oil on panel, 16³⁄₈ x 22³⁄₄" (41.6 x 57.8 cm). Jamee and Marshall Field Loan to the Art Institute of Chicago.

upright by stretching two ropes across the room, catching the top of the frame. Rembrandt Peale offered to reinstall it for exhibition and he upholstered the room and the floor with green baize, hung the picture so that daylight would fall across the surface, not into the viewers' eyes, and he placed a mirror so that upon entering the viewer could not see the painting until in the proper position for a full view. They charged twenty-five cents. The painting elicited many comments.[18] William Dunlap wrote: "His Danae is his greatest and most splendid production. It is indeed his great work; and for that very reason it is on every account, to be regretted, that both in the subject and the style of execution it offends alike against pure taste and the morality of the art."[19] Latrobe wrote in 1805: "It is a *foolish* thing in an artist to chuse a subject which he either dare not exhibit, or if he does expose it, which sacrifices his moral character at the shrine of his Skill," and Charles Willson Peale confided to Latrobe, "Such subjects may be good to shew artists, but in my opinion not very proper for public exhibition. I like no art which can raise a blush on a lady's cheek."[20] The painting continued to be the topic of lively discussion in eastern America. The admission fees made during its tour made Wertmüller a wealthy man. William Dunlap wrote again, "Our ladies and gentlemen only flock *together* to see pictures of naked figures when the subject is scriptural and called moral."[21] Wertmüller made at least one copy of this painting in a smaller format, which Harriet Manigault saw when visiting her friends the Lyle sisters at the Woodlands in 1814. She wrote: "There is a small Danae in Uncle James' room, which is also very correctly concealed by a curtain. The attitude of it is frightful; she is on the point of receiving Jupiter in the shape of a *shower* of *gold*."[22]

Paintings like Wertmüller's brought art into the everyday lives of the public, the patrons, and the community of artists. The extensive notice it received focused public attention on painting, and when Charles Willson Peale brought Wertmüller into his exhibition program of the Columbianum, conservatives were critical. Other artists like Charles Willson Peale had tried their hands at nudes, but the painted nude was not publicly exhibited until the *Danae* appeared. Even the exhibition of casts of classical figures at the Pennsylvania Academy of the Fine Arts was subject to prejudice about propriety, and men and women viewed them on separate days. Peale wrote to Jefferson in 1811: "I think we should guard against familiarizing our Citizens to sights which may excite a blush in the most modest. The artist may always find subjects to shew his excellence of colouring etc., without choosing such as may offend modesty. Therefore at our last Exhibition at the Academy of Arts, I advised and procured some old pictures of Nudities to be put out of sight."[23]

Charles Willson Peale was the Renaissance man in Philadelphia arts between 1785 and 1825; he was both patron and artist. His broad interests encompassed the natural sciences, museology, and art, and the combination of his interests and his painting set the pace for his talented family, and for many active artists in Philadelphia. A well-trained painter who studied in London in the studio of Benjamin West, he had the reputation of being a sophisticated, genial fellow. It was through his efforts that Philadelphia moved ahead in the study and presentation of the arts. The Columbianum, which he organized in 1794, held the first public art exhibition in 1795 in the United States and his *Staircase Group* (pl. 21) is a witty, sensitive, and complex composition that has delighted viewers since the day it was exhibited there. As a family, the Peales took art seriously. Each member of the family followed a particular direction and since all painted with some wit as well as earnestness and skill they were influential in developing the great variety of subjects, techniques, and directions that later painters continued and developed. James Peale studied with his brother Charles and began with traditional portraits and an occasional still life and finally specialized in miniatures (see fig. 51). Raphaelle became the family expert at trompe l'oeil and still life (see fig. 50), and his artistic tricks in such paintings as *After the Bath* became great favorites with Philadelphia artists. Titian Peale specialized in scientific illustration, combining his father's interests with his own talents; he was also interested in collecting. Charles Bonaparte, Zénaïde's husband, sponsored Titian Peale's Florida expedition. The extravagant collector's cabinet (fig. 52), typical of English examples made in the late eighteenth century to display colorful shells collected from exotic places, was made in Philadelphia, probably for a conchologist, perhaps Isaac Lea. In 1886 Lea's will stated that there be no inventory but that his daughter Frances should inherit "my collections of natural history . . . and my *cabinet* of gems, many of which even the smallest ones are important, in a scientific point of view, as the labels appended to them indicate."[24] Charles Willson Peale "collected" people in his gallery of statesmen of the independence period; his museum opened to the public in 1796 with its growing display of natural curiosities. Others collected European paintings, or minerals, or artifacts from distant cultures. Collecting with purpose and vision was a new phenomenon in this period. As the exhibitions organized by the Pennsylvania Academy of the Fine Arts became a regular occurrence, an audience developed and the fine arts entered the mainstream of Philadelphia life.

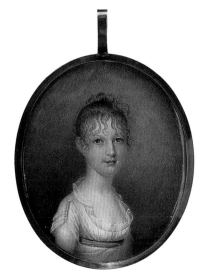

Figure 51
Portrait of a Young Lady, typical of the miniatures that became a specialty of James Peale (American, Philadelphia, 1749–1831), 1805. Watercolor on ivory, 2⁷⁄₈ x 2¹⁄₄" (7.3 x 5.7 cm). Philadelphia Museum of Art. Gift of Jeannette Stern Whitebook in memory of Louise Stern Shanis, 1984-102-1.

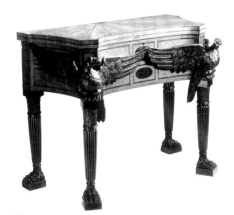

Figure 52
Collector's cabinet, with a mirrored interior divided into numerous compartments probably for the display of shells. American, Philadelphia, 1808–10. Mahogany, satinwood, white pine, tulipwood, and metallic powders, 31 x 47" (78.7 x 119.4 cm). The Henry Francis du Pont Winterthur Museum, Delaware.

Tambour Desk

Plate 20
Tambour Desk
Attributed to Daniel Trotter (American, Philadelphia, died 1800) and Ephraim Haines (American, Philadelphia, 1775–1837)
1790–1805
Mahogany, white cedar, maple, and silver, 45³⁄₄ x 58³⁄₄″ (116.2 x 149.2 cm)
Philadelphia Museum of Art. Gift of Mr. and Mrs. R. Alexander Montgomery, 1984-98-2

In *The Cabinet-Makers' Philadelphia and London Book of Prices* published by Snowden & McKorkle in Philadelphia in 1796, this was called a "tambour writing table" and was distinguished from a desk, which had a case of drawers to the floor under the writing section. The normal size of this table was 36 inches by 26 inches, with one drawer. Each inch "more or less" added one shilling to the cost. This table is very heavy; the secondary woods are thick, the mahogany dense, and the tambour itself, mounted on linen with extra supporting strips of linen, is made from substantial, molded strips of mahogany. The interior is traditional and is fitted with drawers and cubbyholes. The slant of the writing board is adjustable.

Judging by the few extant examples, the tambour technique appeared only for a short period in Philadelphia, although it is one of the most elegant devices for the closing of cupboards and desks. Philadelphia's summers of high humidity may have caused rotting of the canvas to which the strips were glued, or perhaps the mahogany swelled so that the tambour could not maneuver in the grooves.

Robert Waln, who owned this table, was a merchant and self-styled author who had a fine library (pl. 9). In his most prosperous years, from 1785 to 1800, he married, built a new house on Second Street, which he wallpapered and furnished from the best shops, and ordered a new carriage from David Clark. Daniel Trotter supplied him with most of his new furniture between 1794 and 1799, and this tambour desk may be the "new table" that he purchased from Trotter on June 15, 1797, for £12.7. Trotter was working in the old style of solid wood and strong, heavy construction preferred by many Philadelphians. Ephraim Haines, Trotter's apprentice in 1791,

later his son-in-law, and finally shop proprietor in 1799, is credited with adapting designs from Sheraton in a more modern style. This writing table is a handsome example combining late eighteenth-century Philadelphia shop practice with new designs adapted from books by native-born and trained craftmen. Robert Waln may have ordered the swirling, silver-plated candle arms that are fastened to each side of this desk, which were easily obtained from English sources by catalogue or as regular stock in a silversmith's shop.

The silver content of the script "W"s affixed to the sides of the desk reveals that they were probably made in Philadelphia. Their design is exactly like the "W"s on the porcelain that Waln ordered and brought back from China. The size and the weight of the letters suggest that they may have been originally from the doors of a coach; Waln owned a sulky and a chariot in 1794. Many Philadelphia coaches were ornamented with painted cyphers, crests, and coats of arms, but it would have been "showy" for a Quaker like Waln to adorn his carriage with silver initials. Joseph Richardson's silversmith's accounts show that he made a large silver "S" for Robert Smith in 1799 costing a tidy amount (£.1.17.6) although there was no indication of use. Waln had many dealings with his fellow Quaker Joseph Richardson, but nothing in the record pertains to such silver letters. They could also have ornamented an important box or a trunk; they are too fine to have been coffin furniture, which was often imported from Birmingham, England, and was made of inferior metals. If Waln himself placed these silver letters on his desk, it must be a unique and splendid example of the pride of ownership.

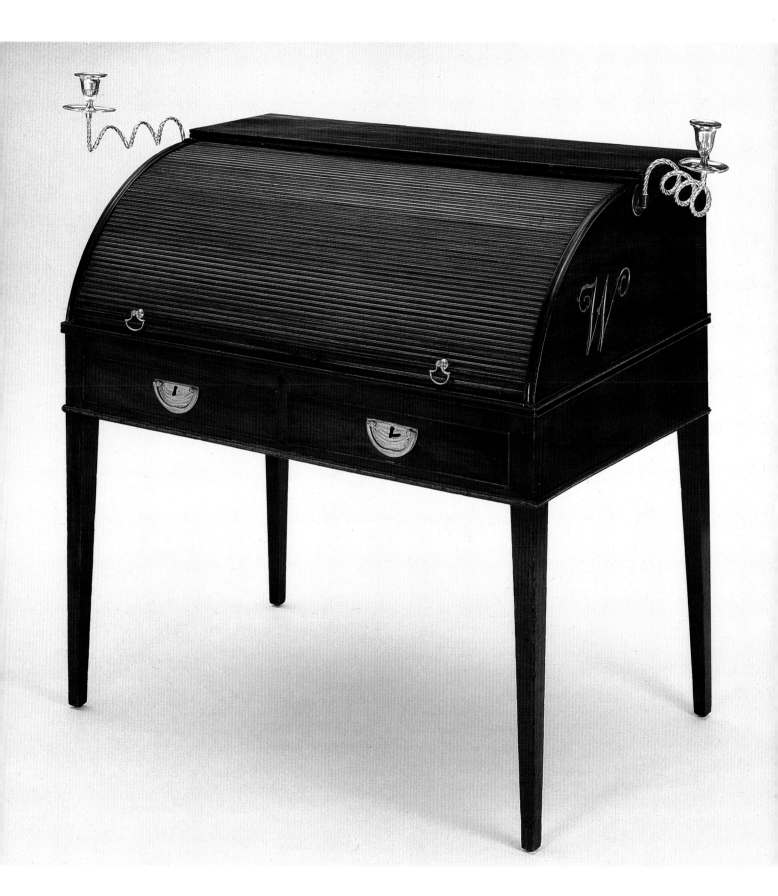

Plate 21
Charles Willson Peale (American,
1741–1827)
Staircase Group
1795
Oil on canvas, 89⅝ x 39½"
(227.6 x 100.3 cm)
Philadelphia Museum of Art. Purchased
for the George W. Elkins Collection,
E45-1-1

Charles Willson Peale, one of Phila-delphia's most inventive artists, was by nature an experimenter. This life-size painting of his sons Titian and Raphaelle was intended to bring the viewer into the space of the twisting staircase setting. It was installed in the Columbianum exhibition in the State House in a doorway with an actual step—two risers and a tread—protruding into the viewer's space. A daring composition, it demanded the viewer's attention. George Wash-ington is said to have nodded to the figures as he entered the exhibition. Thomas Sully may have been inspired by *The Staircase Group* when he painted a life-sized portrait of Samuel Coates standing at his desk in the Pennsylvania Hospital in 1813, about which Samuel Coates wrote in 1818 that "the widow Davey seeing my picture by Sully very suddenly in going up stairs and supposing it to be Me; queried in these words 'Friend Coates which room must I go into to see West's painting?' "[25]

Trompe l'oeil was a favorite artistic challenge in Philadelphia and this painting was the most original composition in the genre produced up to 1794. In design it is complex. Peale selected a tight space: the spiral staircase in a typical three-story Philadelphia house. He set the robust figures of his sons into the space in an upward spiral design to increase the illusion of the architec-tural space. The mahlstick and the clustered paint brushes grasped in Raphaelle's hands connect the fig-ures, stabilize the composition, and establish another level of spatial depth, which moves from the real wooden step, to the painted step with the ticket, to the position of Raphaelle's striding feet, to the implied position of Titian's left leg. The tilt and twist of Titian's pose convey the tight space beyond our view, while his protruding knee anchors him firmly in the composi-tion. The realism of the wooden steps is obvious; the wallpaper and its banding at the baseboard level suggest that it may have been posed in Peale's own house.

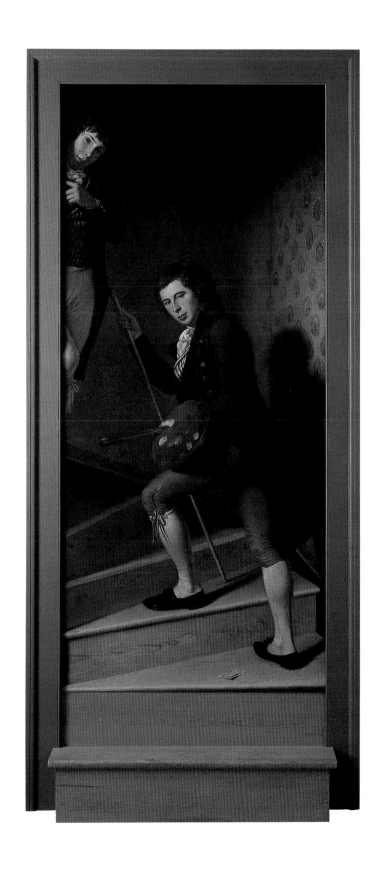

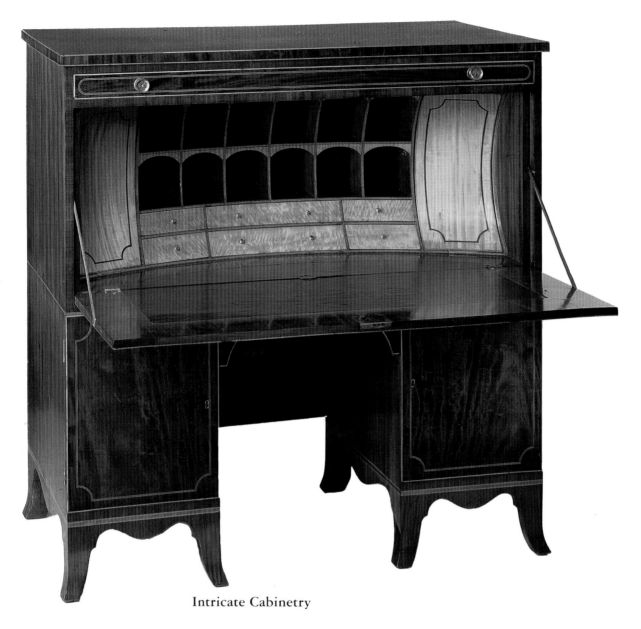

Intricate Cabinetry

Plate 22
Desk
American, Philadelphia
1785–1800
Mahogany, satinwood, holly, white pine,
and spruce; height 53″ (134.6 cm)
Philadelphia Museum of Art. Gift of
Miss Julia E. Purviance, 51-94-1

Family history entitled this "Madame Rush's desk," referring to Julia Stockton Rush, wife of Dr. Benjamin Rush. A widow for thirty-eight years, she was living with her daughter Julia R. Williams (Mrs. Henry J.) when she died in 1848, as the inventory of her estate shows. She bequeathed all her "old furniture" to her daughter Julia Williams. This desk descended in the Williams family until given to the Museum.

The exterior of this desk closely resembles two others,[26] but the interior is different: it is distinguished by skillful execution of a double convex curve, which is carried out horizontally and vertically. The cabinet work, especially in the boxes of drawers, which are behind the inlaid satinwood doors, is superior. These side units can be removed by a spring mechanism to reveal three small, secret shelves.

Exquisite Variety

Philadelphia silversmiths produced some of their most sophisticated and independent designs during the Federal period. These three cream pots, by Daniel Dupuy, Christian Wiltberger, and Joseph and Nathaniel Richardson, are typical of the best small-shop production of the period and show how urbane Philadelphia craftsmen could be when designing and making an object even as unpretentious as a cream pot. They are small but lively forms with eye-catching details, especially in their handles, which are made in swinging loops with additional spurs and fillips. The handle dominates the design of the Dupuy pot. Surface decoration on the other two takes precedence. Wiltberger gave the body of his pot classical fluting and the Richardsons encircled theirs with a gentle interpretation of Roman garlands, which were also a design feature of the neoclassical period and one which would be revived again at the end of the Federal period as applied cast ornament.

The shape of these pots is based on that of an upsidedown Roman helmet, which was one of the classical shapes favored in this period. Philadelphia silversmiths working from models or engraved patterns and designs worked out especially handsome variations of shapes and added decorative elements from the prevailing classical vocabulary such as fluting, beading in bands and garlands, acorn- and urn-shaped finials and knops, and plinth-shaped bases on ball feet. The engraving, chasing, and *repoussé* work was restrained during the Federal period, and on the best of the pots, like Wiltberger's, the surface ornamentation complemented and did not detract from the clean neoclassical shape of the pot.

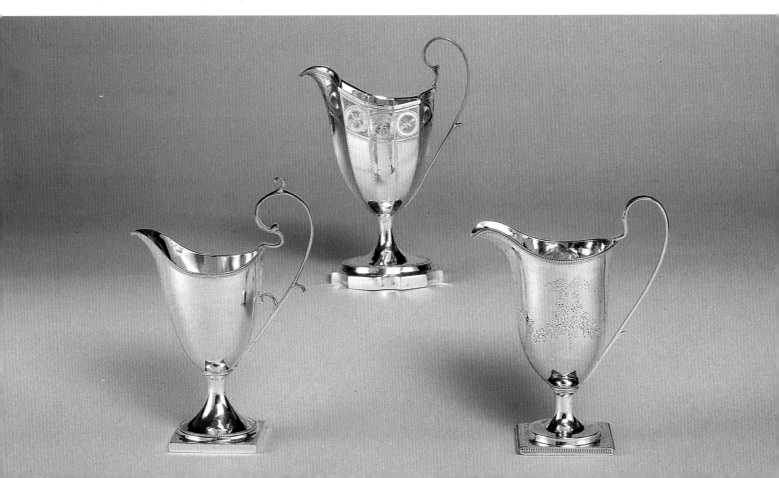

Painted Suite Inspired by Antiquities

Plate 24
Part of a Suite of Furniture: Card Table, Side Chairs, and Pier Table, in an installation approximating an original setting.
Designed by Benjamin Henry Latrobe (American, born England, 1764–1820)
Made by Thomas Wetherill (American, Philadelphia, died 1824)
Possibly painted by George Bridport (American, born England, before 1794–1819)
1808–10
Gessoed, painted, and gilded tulipwood and maple, with cane; height of pier table 41½" (105.4 cm)
Philadelphia Museum of Art. Card table, pier table, and side chair: Gift of Mrs. Alex Simpson, Jr., and A. Carson Simpson, and Purchased with funds contributed by various donors, 1986-126-1,3,4. Side chairs: Gift of Marie Josephine Rozet and Rebecca Mandeville Rozet Hunt, 35-13-9,10

Joshua Gilpin brought architect Benjamin Henry Latrobe and patron William Waln together in 1805. Latrobe had written to Gilpin that he was eager to see a "rational house" built in Philadelphia.[27] Latrobe was not proud of his only private commission before 1805, Sedgeley on the Schuylkill, because he did not supervise the construction and the style required specialized details with which Philadelphia craftsmen were unfamiliar. In his final agreement with Waln he required that he have charge of the work. Latrobe's own descriptions, a drawing done in 1847 and an insurance survey of 1824 show that William Waln's house at the southeast corner of Chestnut and Ninth streets introduced an entirely new urban house style into Philadelphia's cityscape. It reflected Latrobe's London experience and training as well as his intellect and imagination. Besides presenting Waln with two complete sets of drawings for alternative schemes, Latrobe wrote a thoughtful exposition of his philosophy about the conveniences in dwelling houses. His subtle introduction of French niceties must have impressed Waln because Latrobe's scheme, which was carried through to the interior decor, had a decidedly French flare. Latrobe wrote: "In America our manners are English, but our climate is in almost every particular the contrary climate of the British Islands. Our buildings however are exact copies of those erected in Great Britain especially the dwelling houses of our cities . . . The climate of France being both less moist and generally much warmer than that of England, has led the French architects to arrangements of their houses which might be introduced with great advantage into our country. But as that chan[ge] of our manners which the difference of a climate slowly, but

certainly will effect, has not yet made any very great progress in the middle and northern states, a house, compleatly arranged on french principles, would be as illy adapted to the habits of life of an American family, as a house compleatly on the London model is to its health and comfort. . . . It cannot however be denied . . . that in the important points of convenience and privacy the french designs are as superior to those of England as the latter are to the french in neatness, and correctness of execution."[28]

Latrobe's plans were ready in 1805. The insurance survey of 1824 described the principal floor as having "two large parlours on the South—one smaller do in front—vestibule, large hall, & pantry closet . . . one Italian marble mantle highly ornamented & two common do with fluted columns—recess closets, all the main doors are of mahogany—folding door between the large parlours. Two large windows on the South side, with side lights running down to the floor—glass 12 by 20 in."[29] On August 21, 1808, Latrobe wrote to Waln in New York that the floors of the "drawing and dining room will both be laid."[30] On August 7, 1808, Latrobe had written to George Bridport, his "decorative architect": "I have resolved to decorate his [Waln's] drawing room friezes, so picture more than two feet broad with Flaxman's *Iliad* or *Odessey* in flat Etruscan color, giving only outline on a rich ground."[31] Bridport accomplished this; Latrobe referred to it in a letter to Joseph Norris in June 1809, and the 1824 insurance survey referred to "the ornamental painting in the drawing room." On September 8, 1809, Latrobe wrote to Dolley Madison about furnishings for her drawing room: "There is in Philadelphia a Carpet, for which I gave directions in

London for Mrs. Waln . . . It would exactly suit in style and colors the Curtains of your drawing room [red, light blue, and yellow], as Mrs. Waln, is in a very distressing state of health, and her drawing room will not be furnished this winter I can obtain the Carpet for you, if there is enough of it. Rae will bring on a piece."[32] Red, blue, and yellow in varying intensities were colors Latrobe preferred.[33] Latrobe's letter to Waln of August 21, 1808, stated: "I shall see a pattern chair tomorrow morning. I have ordered the cushions to be takable off as I proposed. For the library the chairs will be something different from the Gilpin pattern, of mahogany as settled. For the temporary drawing room chairs you will I presume go to Burden's shop."[34] Latrobe may have consulted Samuel Wetherill, the major paint manufacturer in Philadelphia, about his

painted furniture projects. He had written to Wetherill in 1808, introducing Bridport, who bought paints on account for his painting at the House of Representatives in Washington, D.C.[35] Wetherill would have recommended his nephew Thomas Wetherill, a house carpenter working at 324 South Front Street. Wetherill's inventory taken after his death in 1824 revealed that he had all the tools necessary to make this furniture, including, "2 circular saws with fixtures, 5 turning lathes with tools, set of carpenters tools and work bench."[36] He signed "Thos: Wetherill" in a bold, florid script on the pier table behind the mirror, suggesting that he gave this commission special attention. Latrobe designed other furniture "to be of pine painted," for the Bank of Philadelphia in June 1808, and then in August 1809, he sent his drawings

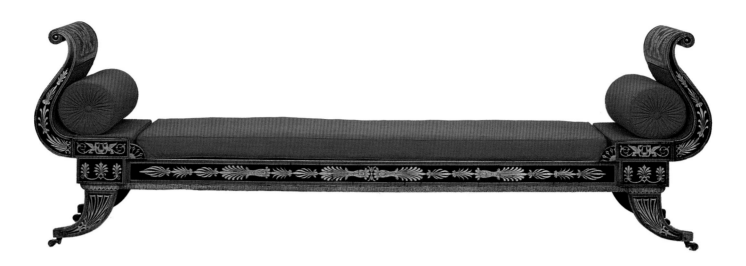

Plate 25
Sofa
Designed by Benjamin Henry Latrobe
Made by Thomas Wetherill
Possibly painted by George Bridport
1808–10
Gessoed, painted, and gilded tulipwood
and maple, with cane, 33½ x 103″ (85.1 x
261.6 cm)
Philadelphia Museum of Art. Gift of
Mrs. Alex Simpson, Jr., and A. Carson
Simpson, and Purchased with funds con-
tributed by various donors, 1986-126-2

for Dolley Madison's suite to the
Findlay shop. The shapes
of the Madison and the Waln sets
were antique and were illustrated in
the design books available to
Latrobe: Thomas Hope's *Household
Furniture and Interior Decoration
Executed from Designs by Thomas Hope*
(1807) and George Smith's *Collection
of Designs for Household Furniture and
Interior Decoration* (1808). The earlier
suite for Waln, where the klismos
chairs and sofa match, shows a suave
design, free of any concessions to
structural security. The sweeping
curve and the tapering line to the top
of the ends of the sofa shown in
Latrobe's drawing for the Madison
set match in line and measurement
the ends of the long sofa designed
for Waln.

Who painted this furniture is
still in question, but George Brid-
port's itinerary, training, and skills
make him a likely candidate. When
Latrobe noted in his letter to Dolley
Madison that the furnishings for the
Waln drawing room would not be
completed in the winter of 1809,
Bridport was hard at work for
Latrobe in Washington, D.C., at the
temporary Senate chamber and at

the president's house.[37] Bridport's
training, which Latrobe described as
"under the famous Dixon," a
theatrical scenery painter and
architectural draftsman, and his own
advertisement of his skills as "Dec-
orative painter & Paper Hanger . . .
Drawing Rooms Decorated in the
French, Egyptian, Turkish, Indian,
Chinese, & Gothic Style,"[38]
suggest sophisticated, urbane skills
and possibly experience on one of
the teams of decorators employed
by Henry Holland or Thomas Hope
in 1804. Bridport knew stenciling
techniques and his inventory
included gilding equipment. This
painted decoration shows a sophisti-
cated eye; although the same motifs
are repeated, they are in different
scales to suit the section of furniture
to be ornamented, and they were
derived from the fine engravings in
Recueil des décorations intérieures (see
fig. 41) by Percier and Fontaine,
which was first issued in separate
plates in 1801. Bridport later owned
a copy published in 1812. The side
chairs show a lively sense of orna-
ment and inventiveness, each painted
with a slightly different design. A
small fragment of the original crim-

son damask upholstery—another Latrobe touch—has survived on the frame of the sofa.

Latrobe praised Bridport's skills and thought them superior to those of John Joseph Holland, who had been his decorative painter until Holland left for New York in 1806.[39] Latrobe wrote to his brother-in-law Isaac Hazlehurst, Jr., in February 1808: "Bridport, whom you sent to me, and whom I employed for a month is lost . . . Pray hunt him out for me. . . . He is a very clever fellow, and I think I can make his fortune. I want him here."[40]

William Waln went bankrupt in 1821 and extensive sales of his properties ensued. An advertisement in *Poulson's American Daily Advertiser* on March 7, 1821, for the sale at T. B. Freeman's Auctioneers (Samuel T. Freeman and Co.), Philadelphia, may have described the set: "Splendid Furniture . . . superior Grecian Card Tables, 1 complete set satin furniture Chairs with three Recess and 1 large Sofa to match, sideboard. . . ." The set was purchased by John Rozet, who was active in the French import trade by 1819, and parts of the set descended in his family.

Plate 26
Card Table
Designed by Benjamin Henry Latrobe
Made by Thomas Wetherill
Possibly painted by George Bridport
1808–10
Gessoed, painted, and gilded tulipwood and maple, 29½ x 36" (74.9 x 91.4 cm)
Philadelphia Museum of Art. Gift of Mrs. Alex Simpson, Jr., and A. Carson Simpson, and Purchased with funds contributed by various donors, 1986-126-1

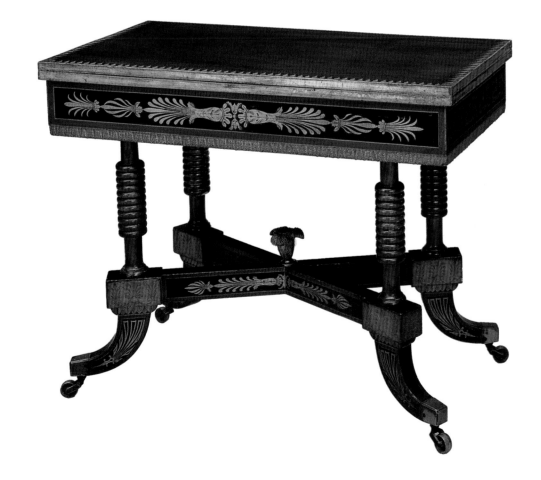

Notes

Victory

1. Beatrice B. Garvan and Charles F. Hummel, *The Pennsylvania Germans: A Celebration of Their Arts, 1683–1850* (Philadelphia Museum of Art, October 17, 1982–January 9, 1983), pp. 17–18.

2. Elizabeth Drinker, Diary, January 11, 1794, The Historical Society of Pennsylvania, Philadelphia (hereafter cited as HSP).

3. Clive E. Driver, comp., *Passing Through: Letters and Documents Written in Philadelphia by Famous Visitors* (Philadelphia, 1982), pp. 48–49.

4. Charles Durang, "History of the Stage," vol. 1, p. 14, HSP.

5. John Cotton, 1815, *The Journal of John Cotton, M.D.* (Marietta, Ohio, n.d.), p. 16.

6. Anthony N. B. Garvan and Carol A. Wojtowicz, *Catalogue of The Green Tree Collection* (Philadelphia, 1977), p. 2.

7. John Penn, Jr., Commonplace Book, 1782–87, HSP.

8. John Penn, Account, April 1, 1788, Shippen Family Papers, vol. 32, HSP.

9. Philadelphia Museum of Art, *Philadelphia: Three Centuries of American Art* (April 11–October 10, 1976), pp. 151–52. The tankard made for Gunning Bedford is now in the collection of the Wadsworth Atheneum, Hartford.

10. David Evans, Daybooks, 1774–1811, HSP.

11. There are two extensive collections of these hardware catalogues, at the Essex Institute, Salem, Massachusetts, and the Victoria and Albert Museum, London.

The Republican Court

1. Rufus Wilmot Griswold, *The Republican Court, or American Society in the Days of Washington* (New York, 1855), pp. 374–75.

2. Griswold, *Republican Court,* p. 376.

3. Samuel Breck, *Recollections of Samuel Breck, with Passages from His Notebooks (1771–1862),* ed. H.E. Scudder (Philadelphia, 1877).

4. Paul Wilstach, *Tidewater Maryland* (Indianapolis, 1931), p. 79.

5. Rebecca Franks to Abigail Franks, August 10, 1781, HSP.

6. Anne Hollingsworth Wharton, *Salons Colonial and Republican* (Philadelphia, 1900), p. 134.

7. Wharton, *Salons,* p. 160.

8. Anita Schorsch, "A Key to the Kingdom: The Iconography of a Mourning Picture," *Winterthur Portfolio,* vol. 14, no. 1 (Spring 1979), pp. 49, 50.

9. Anne Hollingsworth Wharton, *Through Colonial Doorways* (Philadelphia, 1893), p. 225.

10. Joshua Francis Fisher, "Excerpts from a Memoir of Joshua Francis Fisher (1807–1873)," in Harriet Manigault, *The Diary of Harriet Manigault, 1813–1816,* ed. Virginia and James S. Armentrout (Rockland, Maine, 1976), p. 141.

11. Manigault, *Diary,* p. 10.

12. Deborah Norris Logan, Diary, 1817, p. 136, HSP.

13. Drinker, Diary, July 13 and 31 and August 1 and 24, 1794.

14. Logan, Diary, 1816, p. 92.

15. Drinker, Diary, March 23, 1794.

16. J. Thomas Scharf and Thompson Westcott, *History of Philadelphia, 1609–1884* (Philadelphia, 1884), vol. 2, p. 909.

17. Peter A. Grotjan, "Memoirs, 1774–1850," vol. 2, p. 128, HSP.

18. Erskine to Thomas Cadwalader, October 7, 1804, Thomas Cadwalader Collection, box 14, HSP.

19. Erskine to Madison, December 22, 1806, Simon Gratz Collection, case 7, box 19, HSP.

20. Erskine to Cadwalader, December 14, 1806, Thomas Cadwalader Collection, box 14.

21. Register of St. Augustine's Church, HSP.

22. Joseph Donath, Diary, July 22, 1787, American Philosophical Society, Philadelphia.

23. John Neagle, "Hints for a Painter," notebook 3, pp. 41–42, American Philosophical Society, Philadelphia.

24. *The Repository of Arts ,* vol. 1, no. 3 (March 1809), p. 188.

25. Logan, Diary, 1822, p. 76.

26. Illustrated in Harrold E. Gillingham, "William Sinclair, a Pennsylvania Cabinetmaker," *The Magazine Antiques,* vol. 16, no. 4 (October 1929, pp. 298–99. Sinclair's trade card is in a copy of the price book in the library of the Henry Francis du Pont Winterthur Museum, Delaware.

27. George Simson, Bill, 1806, Gilpin Papers, HSP.

28. Similar examples are illustrated in J. Michael Flanigan, *American Furniture from the Kaufman Collection* (National Gallery of Art, Washington, D.C., October 12, 1986–April 19, 1987), p. 185, and Berry B. Tracy and William H. Gerdts, *Classical America, 1815–1845* (The Newark Museum Association, 1963), p. 43.

29. The suggestion that these tables were made by Michel Bouvier first appeared in Tracy and Gerdts, *Classical America,* p. 76. The style of the brass mounts adds to the evidence in favor of a maker such as Bouvier, who was active after 1810. A work table identical to this one and with an incomplete label from a Philadelphia shop is illustrated in *The Magazine Antiques,* vol. 87, no. 3 (March 1965), p. 294.

The Athens of the Western World

1. Scharf and Westcott, *History of Philadelphia,* vol. 1, pp. 447–52. This is the most complete surviving description of the Grand Federal Procession.

2. Gilpin to West, 1803, Gilpin Papers.

3. Robert L. Raley, "Philadelphia's 'First Bank': A Reflection of Dublin's Royal Exchange," in *University of Pennsylvania Hospital Antiques Show,* University of Pennsylvania Hospital (Philadelphia, 1984), pp. 70–74.

4. Philadelphia Museum of Art, *Philadelphia: Three Centuries,* pp. 172–73.

5. John Summerson, *Architecture in Britain, 1530–1830* (Baltimore, 1953), p. 346.

6. Benjamin Henry Latrobe, "Anniversary Oration to the Society of Artists," in *The Correspondence and Miscellaneous Papers of Benjamin Henry Latrobe,* ed. John C. Van Horne, vol. 3 (forthcoming).

7. Thomas P. Cope, *Philadelphia Merchant: The Diary of Thomas P. Cope, 1800–1851,* ed. Eliza Cope Harrison (South Bend, Indiana, 1978), p. 207.

8. William Meredith, Diary, July 12, 1817, HSP.

9. Cope, *Diary,* p. 160.

10. Manigault, *Diary* , p. 97.

11. Edward Shippen Burd, Receipts, 1799, Shippen Family Papers, vol. 14, HSP.

12. William Page, Diary, HSP.

13. Logan, Diary, 1821, pp. 55–56.

14. Logan, Diary, 1815, p. 146.

15. Advertisements for fireboard decorations appeared, for example, in *Poulson's American Daily Advertiser* (Philadelphia) throughout May 1823.

16. Latrobe to John Wickham, December 11, 1816, *The Papers of Benjamin Henry Latrobe,* ed. Edward C. Carter II (Clifton, New Jersey, 1976, microfiche), 134D12.

17. Owen Biddle, *The Young Carpenter's Assistant; or, A System of Architecture . . .* (Philadelphia, 1810), p. 28.

18. Plasterers' Daybook, 1812–18, pp. 26–28, HSP.

19. Meredith, Diary, 1817–21.

20. Manigault, *Diary,* p. 26.

21. The remainder of Robert Waln's library is among the furnishings of Mount Pleasant, Philadelphia.

22. Philadelphia Museum of Art, *Philadelphia: Three Centuries,* pp. 175–76.

23. Philadelphia Museum of Art, *Philadelphia: Three Centuries,* p. 155.

24. John Hewson Will, 1821, Estate Records, City Hall Annex, Philadelphia.

25. *The Cabinet-Makers' Philadelphia and London Book of Prices* (Philadelphia, 1796), pp. 76–77. One of the few surviving copies of this book is in the library of the Henry Francis du Pont Winterthur Museum, Delaware.

Vive la France

1. Thomas Jefferson, *The Papers of Thomas Jefferson,* ed. Julian P. Boyd, vol. 16 (Princeton, 1961), p. 318.

2. Scharf and Westcott, *History of Philadelphia,* vol. 1, p. 469.

3. Scharf and Westcott, *History of Philadelphia,* vol. 1, p. 478.

4. Moreau de Saint-Méry, *Moreau de St. Méry's American Journey,* ed. Kenneth and Anna M. Roberts (New York, 1947), p. 214.

5. Saint-Méry, *Journey,* p. 176.

6. *Poulson's American Daily Advertiser,* May 1, 1823.

7. John Dubarry, Receipt Book, HSP.

8. Karol A. Schmiegel, "Tokens of Friendship," *The Magazine Antiques,* vol. 115, no. 2 (February 1979), pp. 367–69.

9. Robert Morris, Accounts, 1791–98, HSP.

10. Robert Morris, Accounts, 1791–98.

11. Logan to Mary Norris, March 25, 1793, Maria Dickinson Logan Papers, folder 1, HSP.

12. Benjamin Henry Latrobe, *The Journals of Latrobe,* ed. J.H.B. Latrobe (New York, 1905), p. 83.

13. Scharf and Westcott, *History of Philadelphia,* vol. 2, p. 1053.

14. Logan, Diary, 1815, p. 158.

15. Manigault, *Diary,* pp. 132–33.

16. *Poulson's American Daily Advertiser,* May 12, 1823.

17. Manigault, *Diary,* p. 106.

18. James Dallet, Charles E. Peterson, and Phyllis R. Abrams, Curator of the Girard College Collection and Papers, discovered the Faipoux notes and are to be thanked for sharing them for this project. See also Michel Gallet, *Stately Mansions* (New York, 1972), for illustrations of related French ironwork.

A Sense of Style

1. John F. Watson, *Historic Tales of Olden Time, Concerning the Early Settlement and Progress of Philadelphia and Pennsylvania* (Philadelphia, 1833), p. 123.

2. Latrobe to Wickham, April 26, 1811, *Papers of Benjamin Henry Latrobe,* 85C.

3. "Fashionable Furniture," *Repository of Arts . . . ,* vol. 1, no. 3 (March 1809), p. 188.

A Moment in the Arts

1. *Poulson's American Daily Advertiser,* January 4, 1820.

2. *Poulson's American Daily Advertiser,* January 4, 1820.

3. *Poulson's American Daily Advertiser,* January 13, 1820.

4. *Poulson's American Daily Advertiser,* January 1, 1820.

5. Jacob Rozet Will, 1850, Estate Records, City Hall Annex, Philadelphia.

6. Talbot Hamilton, Receipts, 1806, 1808, and 1809, Gratz Papers, HSP.

7. Deborah Norris Logan, "Biographical Sketches of the Life and Character of Dr. George Logan," p. 19, HSP.

8. William Howard Adams, ed., *The Eye of Thomas Jefferson* (National Gallery of Art, Washington, D.C., 1976), p. 96.

9. West to Gilpin, June 16, 1804, Gilpin Papers.

10. West to Gilpin, June 16, 1804, Gilpin Papers.

11. Plasterers' Daybook, 1817, p. 213, HSP, and *Description of the Picture, Christ Healing the Sick in the Temple, Painted by Benjamin West, Esq., President of the Royal Academy, and Presented by the Author to the Pennsylvania Hospital* (Philadelphia, 1817), p. 31.

12. Bonaparte to Hopkinson, September 27, 1822, Hopkinson Papers, HSP.

13. Bonaparte to Hopkinson, March 14, 1819, Hopkinson Papers.

14. William Dunlap, *A History of The Rise and Progress of The Arts of Design in the United States* (1834; New York, 1969), vol. 2, pt. 1, pp. 137, 138.

15. *Poulson's American Daily Advertiser,* February 25, 1819.

16. *Poulson's American Daily Advertiser,* August 31, 1826.

17. Joseph Bonaparte Will, 1845, Estate Records, City Hall Annex, Philadelphia.

18. David Sellin, *The First Pose* (New York, 1976), pp. 24–25.

19. Dunlap, *Rise and Progress of The Arts,* vol. 1, p. 432.

20. Latrobe, *Correspondence and Miscellaneous Papers,* vol. 2 (New Haven, 1986), pp. 105–106n.

21. Dunlap, *Rise and Progress of The Arts* (New York, 1834), vol. 1, p. 418.

22. Manigault, *Diary,* p. 61.

23. Peale to Jefferson, 1811, Peale Papers, American Philosophical Society, Philadelphia.

24. Isaac Lea Will, 1886, Estate Records, City Hall Annex, Philadelphia.

25. Samuel Coates, "Christ Healing the Sick, Pennsylvania Hospital," p.13, HSP.

26. One made for Joseph Hopkinson (see Joseph B. Gilder, "A Pedigreed Antique: The Desk of Joseph Hopkinson," *The Magazine Antiques,* vol. 13, no. 5 [May 1928], pp. 400–401) and a secretary illustrated as plate 405 in William Macpherson Hornor, Jr., *Blue Book of Philadelphia Furniture, William Penn to George Washington* (Philadelphia, 1935).

27. Latrobe to Gilpin, April 7, 1805, Latrobe Papers, Maryland Historical Society, Baltimore.

28. Latrobe, *Correspondence and Miscellaneous Papers,* vol. 2, p. 35.

29. 1824, Insurance Survey, no. 4325, Philadelphia Contributionship.

30. Latrobe to Waln, August 21, 1808, Latrobe Papers.

31. Latrobe to Bridport, August 7, 1808, Latrobe Papers.

32. Latrobe to Madison, *Correspondence and Miscellaneous Papers,* vol. 2, p. 760, and 1820, Joshua Gilpin Letters, Poinsett Section, HSP. The carpet was purchased through Joshua Gilpin's account with Bainbridge and Brown, London, from Woodward and Company for £28.12. He paid for it in 1819. John Rea was Philadelphia's most prominent upholsterer, at 45 South Fourth Street in 1809, after which he moved to 151 and 153 Chestnut Street. In November 1810 Latrobe asked Bridport to go to Rea's shop to find a carpet for the Madison drawing room; thus presumably the Walns were using theirs by that date.

33. Surviving wall painting at the Wickham-Valentine House in Richmond, Virginia, uses a yellow ground with red and blue striping and terra cotta with black line illustrations from Flaxman.

34. Latrobe to Waln, August 21, 1808, Latrobe Papers. In 1809 Joseph Burden was a Windsor chair–maker working at 99 South Third Street and 86 Union Street; in 1813 he was listed as a Windsor and fancy chair–maker at 95 and 97 South Third Street. It might be conjectured that Burden supplied the Walns with substitute furniture until he could complete the designed set. But the uniqueness of the Waln set, in shape and painted decoration, suggests that Bridport, who left Philadelphia and died in the West Indies in 1819, was responsible for the painted work illustrated. Signed Burden chairs are known and have none of the artistic quality of this set.

35. Bridport's accounts with the Wetherill Paint Company are entered in Daybooks nos. 21 and 24, Wetherill Papers, University of Pennsylvania, Philadelphia.

36. Thomas Wetherill Will, 1824, Estate Records, City Hall Annex, Philadelphia.

37. Latrobe, *Correspondence and Miscellaneous Papers,* vol. 2, p. 520n.

38. Edward Croft-Murray, *Decorative Painting in England, 1537–1837,* vol. 2 (London, 1970), p. 176.

39. Latrobe, *Correspondence and Miscellaneous Papers,* vol. 2, p. 344.

40. Latrobe to Hazlehurst, February 1808, *Correspondence and Miscellaneous Papers,* vol. 2, p. 520.